Charcoal, Sanguine Crayon, and Chalk

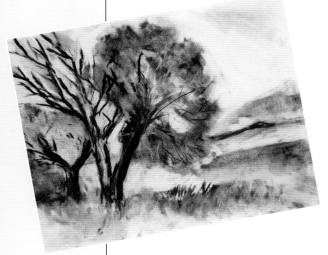

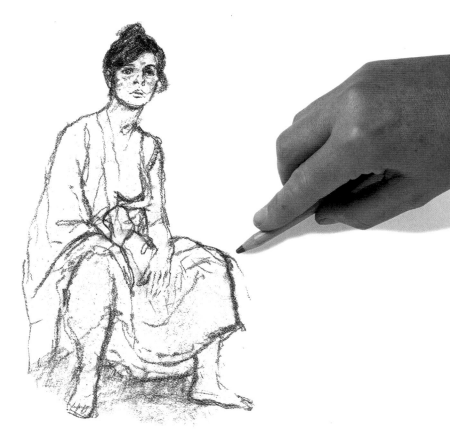

BARRON'S

Original title of the book in Spanish: *Carbón, sanguina, y creta*
© Copyright 2001 by Parramón Ediciones, S. A.—World Rights
Published by Parramón Ediciones S. A., Barcelona, Spain.

Authors: Parramón's Editorial Team
Illustrators: Parramón's Editorial Team

Translators: Michael Brunelle and Beatriz Cortabarria

© Copyright 2002 of English language translation by Barron's
Educational Series, Inc., for the United States, Canada, and its
territories and possessions.

All inquiries should be addressed to:
Barron's Educational Series, Inc.
250 Wireless Boulevard
Hauppauge, New York 11788
http://www.barronseduc.com

Library of Congress Catalog Card No.: 2001056707
International Standard Book No.: 0-7641-2104-9

Library of Congress Cataloging-in-Publication Data

Carbon, sanguina y creta. English.
 Charcoal, sanguine crayon, and chalk.
 p. cm.
"Author: Parramâon Ediciones Editorial Team; illustrators: Parramâon
Ediciones Editoria Team"--T.p. verso.
 ISBN 0-7641-2104-9
 1. Charcoal drawing--Technique. 2. Crayon drawing--Technique. I.
Parramâon Ediciones. Editorial Team. II. Title.
 NC850 .C2813 2002
 741.2--dc21
 2001056707

Printed in Spain
9 8 7 6 5 4 3 2 1

Charcoal, Sanguine Crayon, and Chalk

Contents

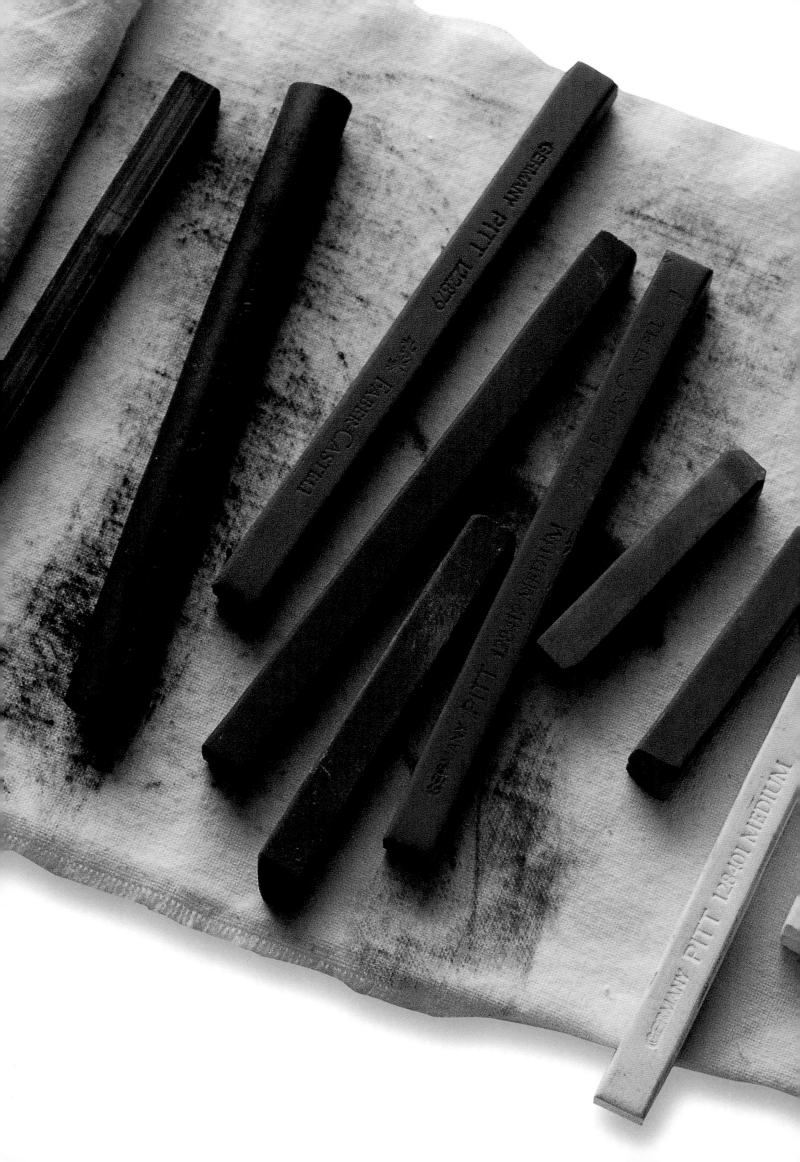

Basic Concepts

For centuries, charcoal and chalk have been the indispensable drawing tools of the great artists. It is not surprising that a charcoal stick is the oldest and most simple drawing tool known. Its origin dates back to the first artistic impressions made by human beings.

Charcoal, as well as chalk, is applied by rubbing, and leaves a very unstable colored mark on the surface of the paper. It can be smeared by simply touching it with the fingers. It is precisely this instability that makes charcoal and chalk ideal media for learning to draw, because they can be corrected very easily, are simple to handle, and produce rich and effective results.

Using this book we will become more familiar with the media. First, we will learn about the minimum required materials needed to begin working, and how to handle them. Next, we will cover the basic techniques: the line, shading and coloring, value, blending, rubbing, and so on. We will demonstrate that each medium has a particular technique. For example, if we are working with charcoal, it is possible to create delicate variations in the shading by blending the lines with the fingers. However, if we are working with chalk, the tones will be stronger and as a result, the

drawing will be more dense and pastel-like. Unlike charcoal, chalk is ideal for working with three or four different colors, and for practicing with white highlights on a medium-tone paper.

The ability to draw and express oneself with chalk or charcoal is not an exclusive talent of few people. Anybody can acquire it by learning the basic techniques and by practicing constantly. Practice is essential to correctly master the medium. Therefore we have devoted the second part of this book to step-by-step exercises, so the reader may learn how professional artists apply the techniques described here. The chapters have been based on exercises created to develop the visual vocabulary of color, lines, and values. Brief but valuable lessons with hands-on exercises share the secrets of working with charcoal, sanguine crayon, or chalk. (Sanguine crayon, or stick, is commonly referred to as "sanguine," and both forms of the term appear throughout this book.) We hope that you can experiment with the techniques described in this book and that you are able to continue developing and broadening your interest in drawing. This book will

teach you the basic skills needed to begin drawing, and it will give you a basic orientation. But remember, nothing can take the place of practice. Learning to draw is like playing a sport or a musical instrument: the secret lies in repetition.

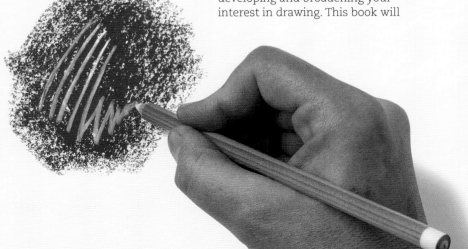

Charcoal, Sanguine Crayon, and Chalk

BASIC CONCEPTS

Materials

for Drawing

Besides the drawing media, whether charcoal, sanguine crayon, or chalk, it is necessary to have paper or some other surface on which to apply them. Furthermore, we are going to talk about the related materials needed for working with these media and for conserving them correctly.

Charcoal Sticks

Charcoal sticks are made of the burnt pieces of certain trees and bushes. They are usually about 6 inches (15 cm) long and their diameter can be from $\frac{3}{16}$ to $\frac{5}{8}$ inch (0.5–1.5 cm). They are available in different grades: soft, medium, and hard, according to their original material or the way they were burnt. They are sold by the box or by the stick. Each charcoal stick has its own characteristic "black," a deep gray color.

It is available in other forms, such as bars of compressed artificial charcoal or powdered charcoal.

Pencils and Large Sticks

Like charcoal, sanguine and chalk also are available in stick form. The thickest are about $\frac{3}{16}$ inch (5 mm) in diameter and their length is about the same as that of the square sticks. The thinnest ones are surrounded with a wood sheath, and are referred to as charcoal, sanguine, and chalk pencils (the latter are colored to match the color of the chalk). The sticks in these pencils are somewhat thicker than the leads of conventional pencils.

Paper

A surface is required for drawing with charcoal, sanguine, or chalk; paper is most generally used for this. Except for those with glossy finishes, any one that the medium will adhere to can be used. Sketching paper, watercolor papers, even cardboard can be used. Conveniently, there are special papers available in a wide range of colors. There is a huge variety, in loose sheets, or in drawing pads or spiral-bound books.

Besides the quality of the paper, the size and format are important issues. The landscape format, that is, rectangular, is the most common. They range from drawing pads that measure 12 × 16 inches (30 × 40 cm) to loose sheets measuring 20 × 26 inches (50 × 65 cm).

Blending Tools

Blending brushes can be of various sizes. They are not the only utensil that can be used for blending, one of the basic techniques of drawing. Rags, cotton swabs, natural sponges, and so on, are also useful. Any size and type or shape of paintbrush can also be used for blending.

Drawing Board

The paper or cardboard that we draw on requires a support that will keep it rigid. We should provide ourselves with a drawing board made of pressed board or plywood. Its surface must be smooth and without texture. As for the size, it is a good idea for it to be 2 inches (5 cm) larger than the paper on all sides.

Sanguine Crayon

Sanguine is manufactured using a ferrous or iron oxide clay with hematite or iron peroxide, along with a chalk filler. It is usually available in small bars that are about $\frac{3}{16}$ inch (0.5 cm) square by $2\frac{3}{4}$ inches (7 cm) long.

They can be found in several colors, like the characteristic iron oxide, red, brown, sepia, and ochre.

Chalk

Chalk is a white or gray calciferous rock that was formed in foraminiferal layers during the Cretaceous Period. Thanks to today's modern methods, chalk is available in square colored bars slightly thicker than sanguine sticks. Actually, most brands do not differentiate between chalk and pastels. The most significant thing about chalk is that it is baked at a low temperature and becomes slightly harder than pastels. Soft and medium pastels have a cylindrical shape, and are therefore easy to recognize. There are many more colors of chalk than of sanguine, although the selection is not as extensive as that of pastels.

Miscellaneous

To make our work easier, we will also need erasers, the most useful being a kneaded rubber eraser, although rubber erasers and plastic erasers are also helpful; cotton rags, for cleaning hands and tools; thumbtacks, clips, or adhesive tape to hold the paper or cardboard to the drawing board; and a craft knife, scissors, ruler, and triangle for cutting the paper to the required size and shape.

Boxes

There are boxes available commercially that are already stocked with drawing materials that include charcoal, sanguine, and some colored chalk. However, any box large enough to hold the materials that we acquire over time will also work.

More Conservation Materials

We need to provide ourselves with sheets of vellum or tracing paper to protect the work when it is finished. Also, we should have a selection of portfolios for the most common-sized works.

Fixative

We will need a fixative for preserving any drawing made with charcoal, sanguine, or chalk. The most practical ones come in aerosol cans holding 8 ounces (250 g) or more.

BEGINNING TO DRAW WITH CHARCOAL, SANGUINE CRAYON, AND CHALK

Drawing Materials

7

Starting Out

What do we need to start working? We should have a stick and a pencil of each medium, charcoal, sanguine crayon, and chalk. As for paper, it is a good idea to use an inexpensive one for our first attempts. We can begin as soon as we attach the paper to the board.

Paper

Any sketch paper will work for drawing with charcoal, sanguine crayon, or chalk. A simple one like the nonglossy side of a piece of wrapping paper can be used. However, using a white or beige paper will result in a brighter drawing.

There are several characteristics of paper, besides its color, that are important. One is saturation. That is the point at which the paper, no matter how much we try, will not take any more of the medium. Another aspect that is important to keep in mind is its texture.

Although we will start out with inexpensive papers, we should eventually practice with good papers like Canson, Ingres, Rembrandt, or Schmincke, to become familiar with their characteristics and the effects achieved by using the textures on either side.

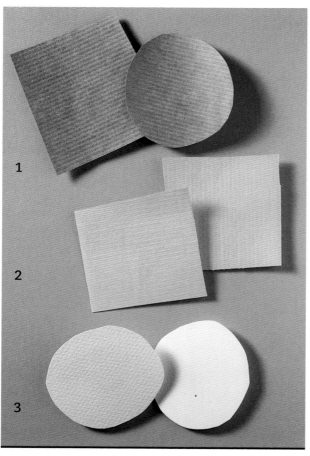

Charcoal

We will begin by using a charcoal stick about $\frac{1}{4}$ inch (0.6 cm) in diameter. Most of these have foil paper wrapped around the top half. This protective cover keeps our fingers clean when we hold it for drawing. It must be removed as the stick is used up.

It is also a good idea to get a carbon pencil, also known as a Conté crayon. The lead is a vegetable charcoal and contains binders. The charcoal and the lead of the Conté pencil act differently when they are applied, as will a stick of artificial compressed charcoal with which we can become familiar later.

Sanguine Crayon

The hardness of a sanguine stick is such that there is no need for a sanguine pencil. However, it will be a good exercise to practice with both. The most common sanguine crayons are red and sepia. Use whichever color you prefer.

Chalk

Although any color can be chosen, how about if we start with blue? A stick and a pencil of white chalk will be very useful when working with charcoal and sanguine, and even with colored chalk.

1. Wrapping paper has a glossy side, so the other should be used for drawing.
2. Each paper has its own tooth, or texture. When a paper with lines, like this yellow one, is attached to the drawing board, different results can be achieved depending on whether it is oriented vertically or horizontally.
3. Using the smooth side or the textured side will result in different effects when applying the media to them.

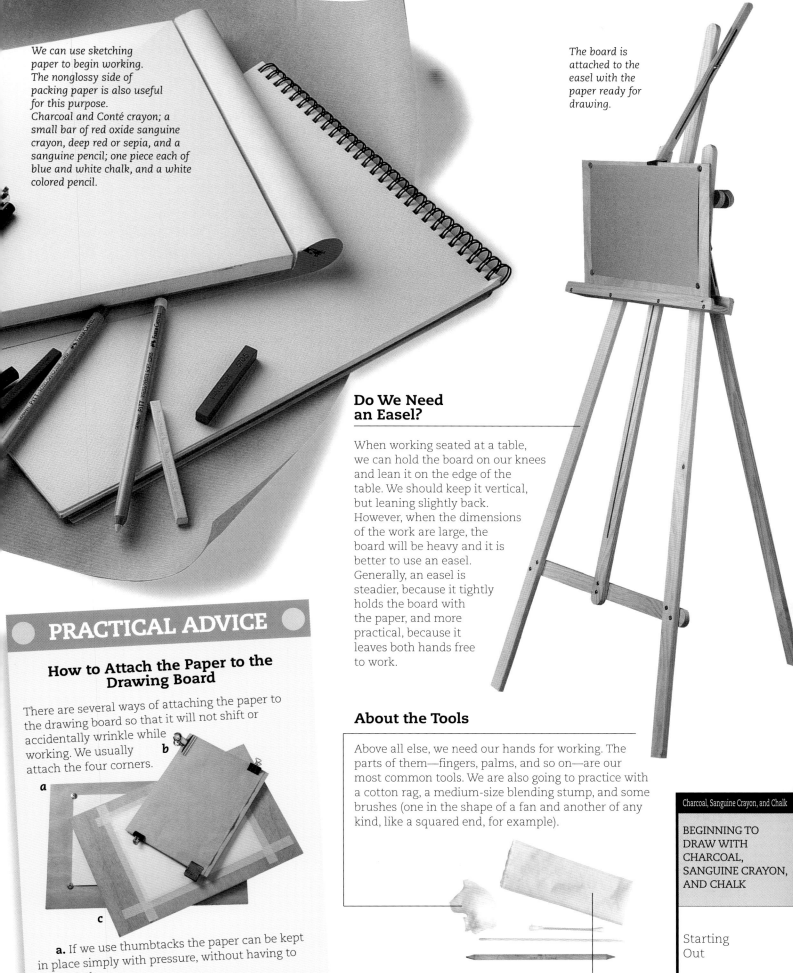

We can use sketching paper to begin working. The nonglossy side of packing paper is also useful for this purpose. Charcoal and Conté crayon; a small bar of red oxide sanguine crayon, deep red or sepia, and a sanguine pencil; one piece each of blue and white chalk, and a white colored pencil.

The board is attached to the easel with the paper ready for drawing.

How to Attach the Paper to the Drawing Board

There are several ways of attaching the paper to the drawing board so that it will not shift or accidentally wrinkle while working. We usually attach the four corners.

a. If we use thumbtacks the paper can be kept in place simply with pressure, without having to punch holes.

b. Clips also avoid making holes on the paper, but they should be large enough to clip the board and the paper, which is always smaller in size.

c. Masking tape is without a doubt the most stable system for attaching paper, but special care is needed when removing it so the paper does not tear.

Do We Need an Easel?

When working seated at a table, we can hold the board on our knees and lean it on the edge of the table. We should keep it vertical, but leaning slightly back. However, when the dimensions of the work are large, the board will be heavy and it is better to use an easel. Generally, an easel is steadier, because it tightly holds the board with the paper, and more practical, because it leaves both hands free to work.

About the Tools

Above all else, we need our hands for working. The parts of them—fingers, palms, and so on—are our most common tools. We are also going to practice with a cotton rag, a medium-size blending stump, and some brushes (one in the shape of a fan and another of any kind, like a squared end, for example).

A Practical Habit

Cotton rags are indispensable. Rags can be made from any old bedsheet. We will need many of them and they will be used for several purposes. During the project they will be used, for example, for touching up the charcoal, the sanguine, or the chalk, as well as for continually cleaning our hands.

Basic Considerations

All of these media—charcoal, sanguine, or chalk—are very fragile. Care must be taken to use them and store them without causing damage. Also, they are very volatile and easy to smear, which forces us to come up with ways to conserve the drawings.

Small sticks and pencil leads break very easily.

Breakage

A piece of charcoal or a small stick of sanguine or chalk can break easily. Simply dropping or tapping them can cause them to split in half. Pencils are somewhat more protected in their wood casings, but when they are dropped or being sharpened the lead can break.

We can protect the materials by wrapping them with a piece of kitchen towel or cotton cloth.

Taking Care of Materials

The stick is held in the hand during the drawing session while taking special care not to drop it or hit something with it. When it is not being used, it must be put in a safe place where it cannot roll or fall, such as inside a box, on top of a cotton cloth, or on the ledge of the easel. We should do the same with the pencils. When we finish the drawing session, each bar is wrapped with a piece of absorbent paper towel or a cotton cloth to keep it clean and protected.

Compartments in the boxes help protect the material properly.

The Composition of Dry Media

Charcoal, sanguine, and chalk are dry media. They are made of completely dry powder particles that are compressed. Charcoal is what remains after burning vegetable matter. Sanguine is a compound of iron oxide and peroxide, and chalk is made of limestone. To make a small stick of sanguine or chalk these materials have to be finely ground until they become a powder. The sticks are shaped by adding water and a small amount of binder. This paste is poured into molds, and the sticks are ready when the paste dries out completely. When they are commercially produced, they are also compressed or even baked at a low temperature.

Volatility

Charcoal, sanguine crayon, and chalk are brittle and basically made of powder. This is easy to see. Charcoal is the most fragile medium, especially the soft kind. It is very easy to crumble between your fingers. A fine black powder and some pieces fall on the paper. If we blow on the powder, only traces remain, which shows that this is a dry medium. If we wipe the surface with a cotton cloth, it disappears almost completely. If instead of blowing, we rub a finger over the powder and the small pieces of charcoal, we notice that we leave quite a mark on the paper. But if we wipe this charcoal trace with a clean cotton cloth, we see that it is very volatile, that is, it is easily removed from the paper, because it is powder. The same happens if we blow on it or wipe a finger across it. Charcoal is the most volatile medium, followed by chalk and, finally, sanguine.

A Decorative Element

The mat, in addition to creating a space between the glass and the piece of work, definitely serves as a decorative element. This must be kept in mind when working with charcoal, sanguine, or chalk. We can choose between understated white, off-white, or beige mats, or other, more colorful ones.

If the mark is wiped with a cotton cloth, a good portion of the powder adheres to the cloth.

Charcoal crumbles easily. When we crush it with our fingers we get powder and small pieces of charcoal.

A significant mark is made on the paper when the powder and small pieces of charcoal are rubbed with a finger.

When we blow on it, only a small trace remains.

Using Fixative

Any accidental contact with such volatile media causes them to smear. Therefore, it is necessary to use a fixative once the work is finished. We should always use it in a well-ventilated area, and it is best if the windows in the room are opened. First, test the spray by aiming into the air and pressing the top to make sure it works properly. The fixative should be applied at a distance of about 6 inches (15 cm) from the work, trying to spray it gently and evenly over the entire surface. The spray is moved back and forth or in circular motions while pressing the button lightly.

PRACTICAL ADVICE

Conservation

Applying the fixative is only the first step in the conservation of work done with dry media. We must protect it with a sheet of tissue paper and store it in a portfolio. This, however, protects it only temporarily. A permanent treatment requires framing the work. Thanks to the mat, a protective space is created between the work and the glass.

Line, Shade, and Color

A line is left on the paper when we apply pressure to the charcoal, sanguine, or chalk. We can make lines, shades, and colors. There is a whole world of possibilities.

To make a wider mark, break off a piece of sanguine.

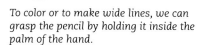

How to Hold the Pencil

The charcoal, sanguine, and colored pencils (with the exception of white, which can be used only for highlights or on colored paper) are used especially for sketching and for hatching. Normally, they are held like any other pencil used for writing. But for shading or coloring large areas, it can be held between just the index finger and thumb, and with the palm of the hand surrounding the pencil.

To color or to make wide lines, we can grasp the pencil by holding it inside the palm of the hand.

How to Hold the Stick

A stick or a piece of stick is usually held with three fingers: thumb, index, and middle fingers. To work on details, a line is drawn with one end of the stick while the other is pointing toward the inside of the palm of the hand. The stick or the piece is held sideways to trace with one side. Fine lines can be made with any side of square sticks.

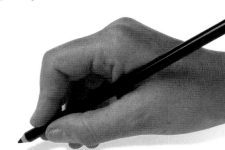

The charcoal pencil is held like this for drawing details or hatching.

How to Hold the Charcoal

An unbroken charcoal stick is quite a bit longer than a stick of sanguine or chalk. It can be held with three fingers, making the line with one end while the other is surrounded by the palm of the hand. When drawing, the wrist is usually turned (with the palm of the hand facing up) so most of the surface of the paper can be reached this way.

To make a wide line, a piece of the charcoal can be broken off and used on its side for shading.

How the charcoal is held when drawing long lines.

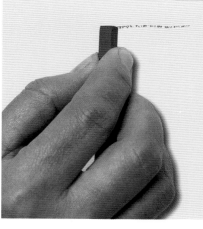

Holding a stick of sanguine to make a horizontal line using the edge of a square piece.

How to hold the sanguine to make a vertical line with one of the edges.

How to hold a piece of charcoal to draw with its side.

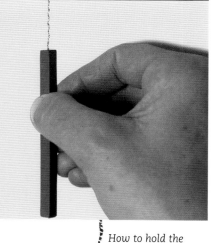

How to hold the charcoal for drawing details.

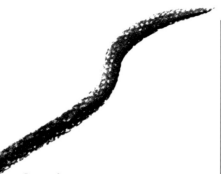

The Line

A line is defined by the fact that its contour has two linear boundaries. In a line we can see its weight, the intensity with which it has been applied (that is, how dark it is), and its direction. From all this, one can deduce the intention with which it was made.

The thickness of the line varies depending on the area of contact of the charcoal on the paper, or on the pressure applied to it.

Line Weight. A line can be very thin or thick, depending on the width of the point of contact of the charcoal, sanguine, or chalk on the paper, although it also depends on the pressure applied to the stick. When a lot of pressure is applied, the expected result is a heavy line at the area of contact.

A progressively more intense line ends up covering all the texture of the paper.

Intensity. When we make a line applying quite a bit of pressure, the result is a line that is very intense, very dark. When we apply less pressure, the line is softer. A very intense line covers all the texture of the paper. A very fine line lets you see the paper through a thin layer of powder.

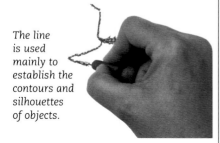

The line is used mainly to establish the contours and silhouettes of objects.

Intention. We can make straight, curved, and mixed lines. We draw lines to reproduce a silhouette or the outline of a shape. Therefore, a line can have straight or curved parts, of varied intensity and thickness.

The Artistic Line

An artistic line is a result of the synthesis of strokes in an outline. But a line of these characteristics requires many hours of practice.

By using the wrist and moving the fingers, we can change directions and adjust the pressure as needed.

Hatching

When a line is used repeatedly, the surface of the paper is covered. Hatching can be done in many ways. As a test, we can practice hatching that is created with more closely spaced lines and another one that is achieved by superimposing a series of lines. The paper is shaded with charcoal hatching, whether using a stick or a pencil.

However, the sharp edges of sanguine and chalk also lend themselves to the application of color through repeated lines. As an example, we can make two types of hatching. One results from superimposing series of repeated lines. The other is based on increasing the color density through the use of many lines.

Shading and Coloring Without Lines

When charcoal is applied without the intention of creating a line, that is, using it to cover the paper evenly, we are applying shading without a line. A piece of charcoal stick is used to do this. The side is used to shade with soft circular motions.

Coloring is done by applying sanguine or colored chalk to the surface without contours that would indicate a line. A piece of sanguine or chalk is used on its side to make light strokes, soft movements that produce an even layer of color.

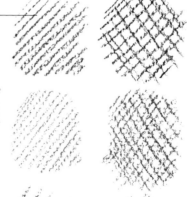

In a more artistic line, we apply varying pressure, creating different intensities.

Hatching with charcoal, sanguine, or chalk is achieved using a series of lines.

Shading with charcoal or coloring with sanguine and colored chalk (without lines) is done by making light circular or back-and-forth motions with the side.

PRACTICAL ADVICE

Helpful Tools

To avoid accidental smearing, you must try to draw without touching the work with your hands. The sanguine, chalk, or charcoal stick or pencil is the only thing that should be in contact with the paper. A maulstick can be used to help maintain a steady hand, but any stick can do the job as well. One end of the maulstick is set outside the piece of work, the free hand holding it away from the drawing, while the one that holds the charcoal (sanguine, chalk, or pencil) rests on it to draw.

It is good practice to leave a clean area around the drawing. When it is an important job, it is worth making a frame and placing it over the paper, for protection.

Maulstick

Frame

Blending

One of the most characteristic tasks that we can perform with charcoal, sanguine crayon, or chalk is blending. Let's look at the effect that is achieved with each medium, the problems that may arise, and the results of using different tools.

Volatility and Blending

Dry media, such as charcoal, sanguine, and chalk, are volatile. This is the attribute that allows us to do the blending. By blending, we mean the act of wiping a cotton cloth or another object over a line made with charcoal, sanguine, or chalk. The result is that the color extends itself on the paper until it fades away.

A Basic Technique

There is a noticeable difference between the effects of a line or color that has been blended and one that has not. This shows us that blending is a basic technique to which we can resort whenever we need to reduce contrast. We blend to tone down the intensity of shading or color. When it is applied to a line, it softens it.

Blending Charcoal

Charcoal is the most volatile of the dry media. Its blending depends on the force applied for removing and extending lines and shading. The bulk of the carbon powder is eliminated very easily. We must practice this type of task if we want to achieve the exact desired effect.

Blending Sanguine Crayon

Sanguine leaves a heavy mark on the paper. It should be applied with care and we should practice blending to become familiar with the results. It is recommended to begin by coloring softly. A light color can be darkened, but one that is too strong, on the other hand, must be softened by blending or erasing. It is very hard to remove the color.

Blending Chalk

Quality blending effects can be achieved using chalk. Since chalk is really a hard pastel, it gives us a glimpse of what it would be like to work with pastels.

The chalk powder is very slippery. It does not adhere as well as sanguine, but it is less volatile than charcoal.

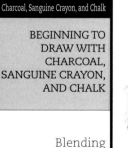

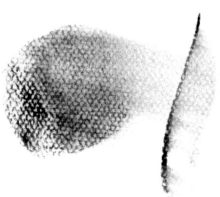

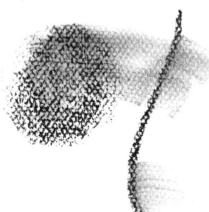

The charcoal line is very different when it has been blended.

When the sanguine is blended, we can see that it is less volatile than charcoal. The shapes of the lines are not as washed out.

Blending with chalk produces very pleasing effects.

What Is Rubbing?

The difference between blending and rubbing is basically its result. Both tasks require wiping the mark with an object, whether a cotton cloth, a finger, or any other tool. But the goal of blending is to remove and extend the color, whereas rubbing seeks to mix tones by repeatedly rubbing the mark. Shading or color is also reduced when rubbing but less than with blending.

The bottom part has been blended, reducing the intensity of the mark. The purpose of rubbing the top part is to even the tones. Rubbing looks darker than blending.

Making Corrections

The act of blending is in reality a form of correcting. In fact, we are removing a certain amount of powder that was attached to the paper. This type of correction changes the effect of the line. Blending also tends to saturate areas of a textured paper (which before were free of charcoal, sanguine, or chalk). This decreases the capacity of the paper to accept more shading or coloring in later applications.

Sometimes, erasing may be needed to finish correcting. A kneaded or plastic eraser makes it possible to recover quite a bit of the color of the paper. Erasing must be done softly so as not to alter the surface of the paper or its ability to hold the media.

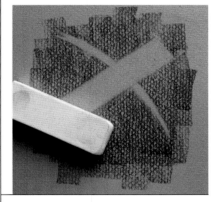

When correcting we can erase large areas with an eraser, always holding the paper tightly to prevent it from wrinkling with the friction.

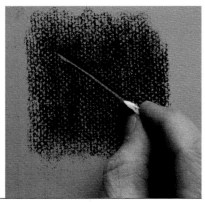

Details can also be erased, even if they are very small or linear.

Tools for Blending and Rubbing

The hand (especially the fingers) and a cotton cloth are the tools most widely used to blend charcoal, sanguine, or chalk. A fan brush, blending stump, cotton swab or cotton ball, and other items are also useful.

Each tool provides different blending effects, depending on the amounts of blending each can do. The cotton swab or cotton ball and the fan brush can be used for soft blending, in which shading and color are reduced without saturating the paper. A cotton cloth covers a large area when blending, but there is not very much control at the edges. Blending stumps, fine brushes, and cotton swabs are all used mainly for blending and rubbing details. They do not remove as much shading or color, but change their effect and more easily saturate the paper.

Each tool produces different effects when used for blending. Here, we use a piece of cloth, a cotton ball, and a cotton swab. It is a good idea to practice with them to get used to their different characteristics.

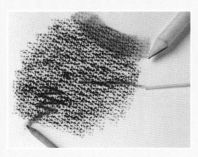

A lot of rubbing is involved in blending with stumps. Even a small wood stick can be useful for rubbing very fine lines.

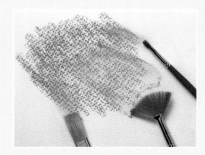

If we apply gentle pressure on the brushes they will produce soft blending.

Tone
and Tonal Range

A tone or tonal value corresponds to the intensity of each line, shade, or color. When we change the intensity by applying varying pressure on the charcoal, sanguine, or chalk, we create different tonal values. We can arrange them from higher to lower or vice versa to obtain a tonal range.

Charcoal

Tone. The difference between two tones is very visible. When we shade without line, it is sufficient to apply an even pressure for one tone and change it for a different tone. If we wish to have a lighter tone, there should be less pressure. If we want darker tone, the pressure should be greater.

We can also create a tonal effect with lines. They have to be repeated, whether points or lines (straight, curved, zigzag, etc.). Lines can create a darker tone when we add more or when several of them are superimposed.

Shading. When we apply charcoal without lines, for example, by using the side of a piece to make light circular motions, we create a shading effect in some areas of the paper.

If we hold the charcoal to draw only with the tip, we can produce hatching. These lines create shading, but their effect is different from shading without lines. Therefore, we have several ways to produce shading.

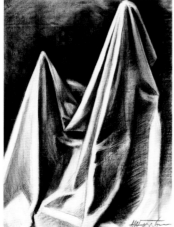

Tonal range, in this case done with charcoal, is needed to represent shadows of the objects.

Charcoal, Sanguine Crayon, and Chalk

BEGINNING TO
DRAW WITH
CHARCOAL,
SANGUINE CRAYON,
AND CHALK

Tone and
Tonal Range

16

Charcoal's Tonal Range

When we arrange the tonal values from more to less or vice versa, we get a tonal range. It can be created by shading without a visible line or with hatching. Always remember that tone can be controlled by the amount of pressure that is applied to the charcoal on the paper, or by covering more or less of the paper as well.

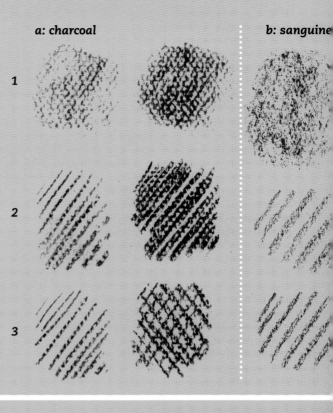

a: charcoal **b: sanguine**

1

2

3

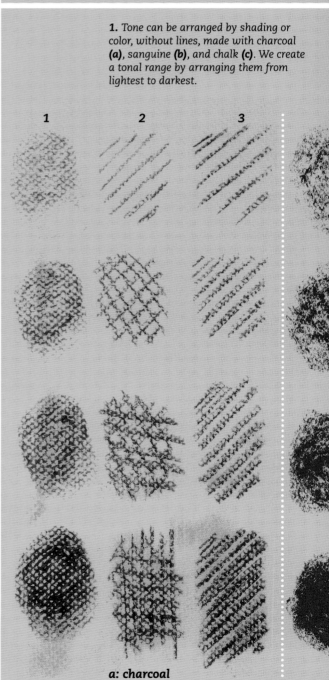

1. Tone can be arranged by shading or color, without lines, made with charcoal (a), sanguine (b), and chalk (c). We create a tonal range by arranging them from lightest to darkest.

1 2 3

a: charcoal

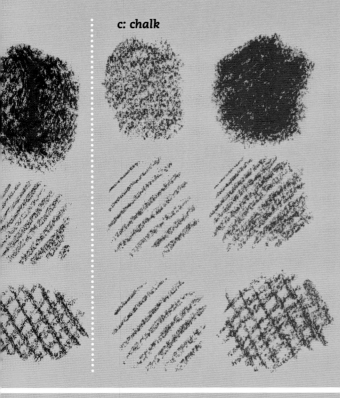

c: chalk

1. *Two tones created by shading without lines: with charcoal (a), sanguine (b), and chalk (c).*

2. *Two tones created with lines by increasing their density: with charcoal (a), sanguine (b), and chalk (c).*

3. *By superimposing two series of lines a darker tone is achieved: with charcoal (a), sanguine (b), and chalk (c).*

Sanguine Crayon and Chalk

Tone. As with charcoal, the difference between two tones of sanguine or of chalk is also very visible. To color without lines, consistent pressure is applied for one tone and another one for a different tone. For a lighter tone, less pressure will be required; for a darker tone, more pressure.

It is very easy to make lines with sanguine or chalk, and they are very common, because they come in small, hard bars whose edges don't wear down. They can produce a darker tone when more is applied or by building up a series of lines.

Color. A color effect can be produced in some areas of the paper when sanguine and chalk are used without lines, for example, by using the side of a stick with light circular motions.

If the bar is held in such a way that the tip or one edge is used for drawing, we can make hatch lines. These hatch lines create color. However, the effect is different from coloring without lines. Therefore there are several ways of coloring.

The Tonal Range of Sanguine Crayon or Chalk

Tonal values can be ordered from lighter to darker or vice versa, to determine the corresponding tonal range. They can be created by coloring with or without visible hatch lines. Remember that tone can be controlled with the pressure that is applied to the paper with the sanguine or chalk, and also by the amount of the surface of the paper that is covered with pigment.

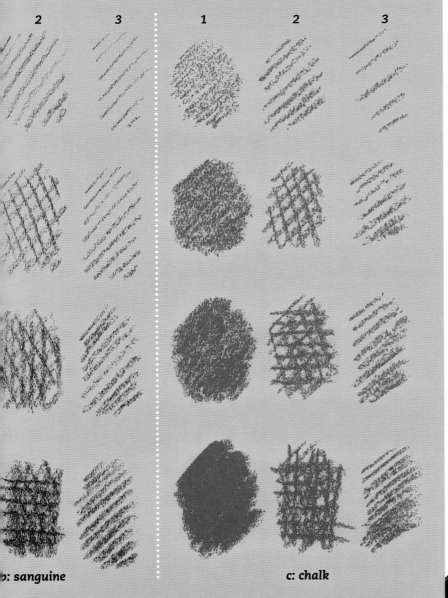

2. *We can shade or color using charcoal (a), sanguine (b), or colored chalk (c) to create crosshatched lines. The greater the number of hatch lines, the darker the tone.*

3. *When we put the different tonal values in order, created by increasing the density of parallel lines, the tonal range looks quite different from the other ranges: with charcoal (a), sanguine (b), and chalk (c).*

| 2 | 3 | | 1 | 2 | 3 |

b: sanguine **c: chalk**

It can be useful to have a holder for sanguine or chalk, like this square one, although it is not essential. Round ones are also available for charcoal and thick leads.

Gradation

Blending Direction

The result obtained from blending a gradation varies according to the direction in which it is done. When the blending is done going from the lighter to the darker tone, the result generally is a lighter tone than when it is done dark to light.

Creating gradations is one of the most common techniques for working with charcoal, sanguine, or chalk. For a gradation we need to use only a tonal range, but apply it gradually to limit abrupt changes between tones. Blending and rubbing are normal techniques that can be used over gradations.

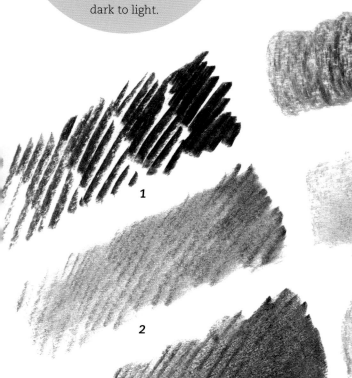

2. Gradations with charcoal can be blended, for example, with a fan brush, to produce an overall lighter tone.

3. When we rub the charcoal gradation with a finger, we create intermediate tones, if they are compared with gradations created with lines or by blending.

1. Examples of gradations with charcoal, showing shading work done with or without lines. The one with lines has visible areas between tones to show more clearly how it is done.

Charcoal, Sanguine Crayon, and Chalk

BEGINNING TO DRAW WITH CHARCOAL, SANGUINE CRAYON, AND CHALK

Gradation

Line Gradation

Gaps between tones can be avoided when using line gradation. The key is to control the intensity of the line and the density of the hatching. This type of gradation can be perfected only with practice.

Blended Line Gradation

When we blend a gradation made with hatch lines, the results will differ, depending on whether charcoal, sanguine, or chalk has been used. Very light blending is achieved by using a fan brush and blowing on it afterward. Charcoal lines disappear easily, and chalk lines somewhat less. Sanguine lines remain virtually unchanged.

Rubbed Line Gradation

When we want to fuse the colors using the finger or a blending stump instead of removing charcoal or color by blending it, the result is also different. The overall tone of the rubbed gradation looks darker than the blending.

Shaded or Colored Gradation

Without the use of lines, shading or coloring depends on our skill in controlling the pressure applied on the charcoal, sanguine, or chalk, which can be seen in the mark made on the paper. The aim is to apply shade or color very gradually from the lightest tone to the darkest.

Controlled Rubbing

The direction of tonal values should always be kept in mind when touching the drawing. If we don't exercise caution and rub the finger to blend without regard for the direction, we will only make darker tones with pigment from other tones.

The artist Bosch has drawn this figure study using lines, coloring, and light gradations with sanguine.

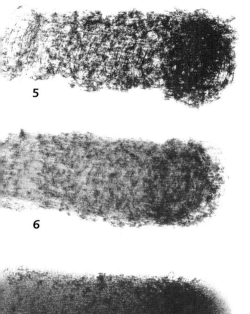

This gradation is done with sanguine and chalk. We can use both media, as well as charcoal, to do coloring with or without lines and to create the same effect as blending or rubbing.

4. Gradations made with sanguine lines going in one direction can be very gradual. The blue chalk lines were applied differently.

5. To achieve graded color without visible lines, the side of a bar, either sanguine or blue chalk, should be used. Pressure is gradually increased using circular or zigzag motions.

6. Gradation can be blended when using sanguine or chalk, in this case blue. If we use a cotton cloth, we will get a different overall tone. The fabric will remove more powder than a fan brush, for example. The overall tone of the blended grading is obviously lighter than the one that has not been touched.

7. If we rub the gradations made with sanguine or chalk with a finger or a blending sick, we get intermediate tones compared with the gradations that have not been touched or that have been blended.

Blended Shadow or Color Gradation

Now we can use a cotton cloth to blend this type of gradation. We can see that the overall tone of the gradation is reduced, but using the cotton cloth adds a certain smoothness to the tones.

Rubbed Shadow or Color Gradation

We will use the index finger to blend the tones. Special care should be taken not to skip any tones. A repeated top-to-bottom movement is used to rub the tones gradually, from lighter to darker. Rubbing the shading or coloring produces an overall tone that is darker than blending.

Tonal Values

One of the most important points is establishing a system that analyzes and relates tonal values. We must learn to plan this by observing the model.

Observing the Model

The light cast on objects is what allows us to see them. When the light changes, our view of them changes. We must always work from a model and specific light that doesn't change. When studying it, it can be useful to squint our eyes. This allows us to distinguish zones in which the overall tone is different.

Tonal Values

Objects, in general, have color. The first thing that we must do is to imagine the subject reduced to black and white with several gray values. This way, it will be easier for us to represent the object with different tonal values.

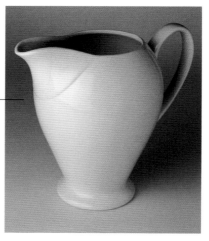

View of a pitcher lit from above.

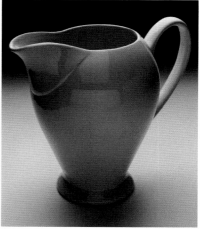

The same pitcher looks different lit from behind.

Light and Shadow

There are two basic tones that allow us to determine the tonal range. The lightest is associated with areas of most intense light and the darkest with those of least light.

A simple still life helps illustrate how relationships can be represented using a system of tonal valuation.

2

1

It is very helpful to imagine the model in its achromatic version, that is, in black and white. Then, with little effort several tonal values can be picked out. Boundaries for different tonal areas can be established on a sketch.

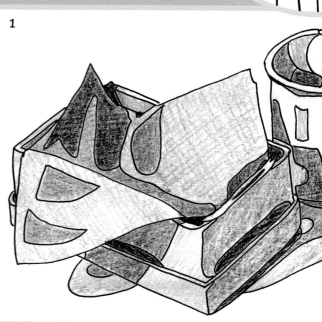

Using the Tonal Range

It is not very useful, in practice, to rely on the tonal range for applying values. A system is usually established based on several tonal values: one very dark tone, several medium ones, and the lightest tone. With five or six values we can begin developing an accurate drawing.

Zone Divisions

Several simple outlines will help us understand what relationships are needed. We can divide the paper in several areas, with lines. Each one of these areas presents a tonal value. It is not difficult to establish the relationship between the areas that are of the same value. It is the system that enables all the tones to relate to each other.

Light and White Paper

When working with charcoal, sanguine, or colored chalk, the white of the paper is the lightest tone that we have. The pure, white paper is used for representing the points or areas that have the most light. It is helpful to be able to recognize the areas that receive the most light in any part of the model.

Highlights are the result of a reflective surface. They appear usually in specific points or areas. It is very important to locate them. They can be represented without difficulty with white chalk, when we use colored paper.

Dark Tones

If the most illuminated areas are important, the darkest ones are no less so. Locating them means defining the shapes not only with the drawing but also through the effect of the light. The darkest tone is reserved for representing the darkest area. The most intense tone obtained with charcoal, sanguine, or chalk will be the one achieved by pressing the medium on paper as hard as the medium allows.

Each tonal area is matched with a value from the range. These are possible tonal values made with charcoal. Different tonal values are also created from the tonal range using sanguine or chalk.

Projected Shadows

The light that falls on an object produces different tonal values on its surface. It also defines a shadow that the object creates on the surface of the plane it rests on or on another object that is near enough. Projections of shadows that are well represented with regard to their edges and their tones help to create a good sense of volume.

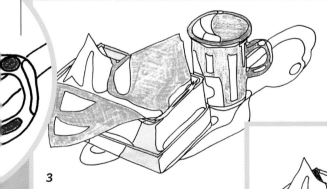

3

4

5

The lightest and the darkest tones are the two most important tonal values that help easily define the represented objects, whereas the quality of the projected shadows helps us understand the depth.
1. We have added shading to a sketch of the outlines of the tonal areas, using the tonal range. We must be able to recognize
2. the highlighted areas,
3. the areas in an object with the most light,
4. and the darkest areas;
5. and study the quality of the projected shadows.

The Sketch

Let's move on to the practice. First, we will measure the object to choose the most appropriate format for the subject, to frame it and lay out the sketch. A sketch has only a few lines, enough to make the outlines of the elements of the model. It is always drawn with light lines, so they can be erased without difficulty until we are satisfied with the sketch.

Measuring

Remember that a series of rules must be observed when making the important measurements. The board and the paper, and the easel if one is used, must be located as we are, in the same position with regard to the model. To measure, we extend the arm and observe the height and width of an object along the pencil or the handle of a brush, while using the thumb to indicate on this guide where the other end would be.

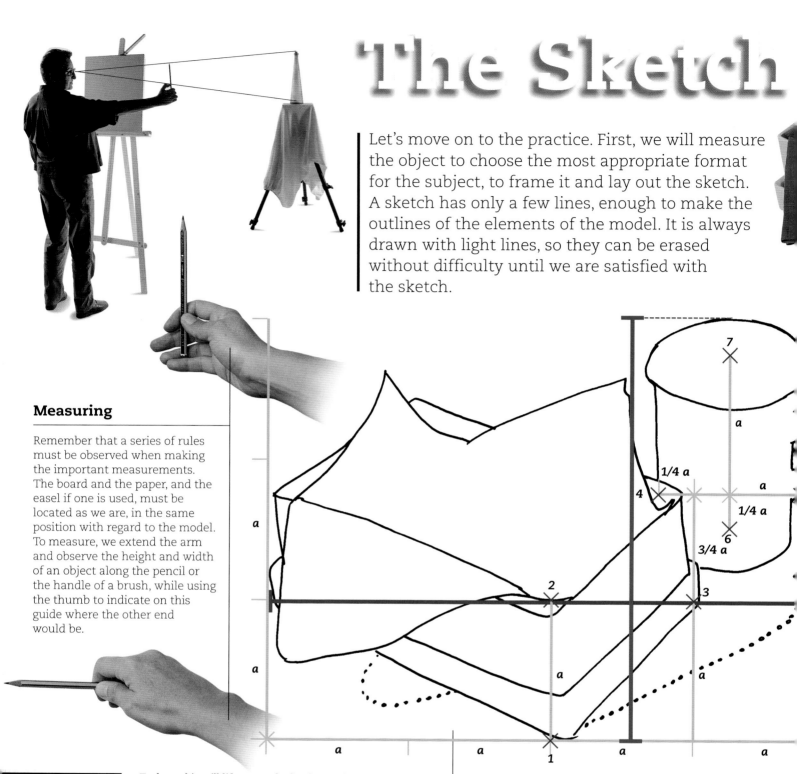

PRACTICE

The Sketch

22

To draw this still life we need a landscape format because the width is approximately 1.5 times the height. It is a good idea to leave a margin around it so the drawing is well centered. By observing the model, one measurement can be isolated (a) which is repeated either vertically or horizontally, and also fractions of this measurement. One way to start would be to divide the area of the framed paper into five sections wide and

three sections high. The important points of intersection that have to be located are in numerical order. Parting from 1, the vertical and horizontal lines and the distance (a) or sections, are numbered as follows: 2, 3, 4, 5, 6, 7, and so on. Once the important points have been established, it is easy to draw the master lines of the sketch.

Important Relationships

To decide what paper format to use and how to center the drawing, two important measurements must maintain their relationship: the total height and width of the model. The areas where the shadows projected by the objects can be seen must be included in the measurements.

Then, we will look for one measurement (sometimes there are two related to each other) that is repeated, horizontal or vertical. This can even be a fraction, as long as it is always simple, such as half, one-fourth or one-third, and so on.

Placement on Paper

The relationship between the total height and width, in a still life like this one, for example, requires that it be placed in a landscape format, because it is wider than it is high. Once the size of the paper has been decided upon, we divide it into sections, based on the measurement that is to be repeated and in proportion to the size of the paper.

Next comes the placement of the first important point. Starting from there, the measurement or its simple fractions are marked vertically or horizontally.

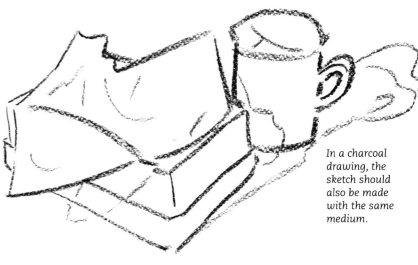

In a charcoal drawing, the sketch should also be made with the same medium.

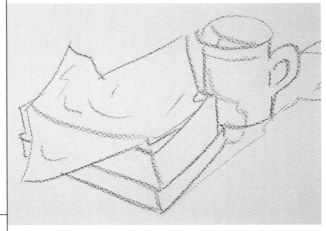

When working with sanguine, we must remember that this medium is difficult to remove and that the sketch lines must be done softly.

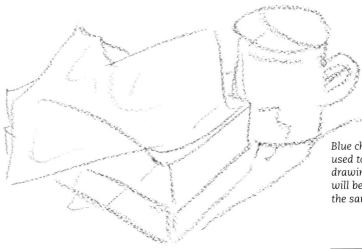

Blue chalk is used to sketch a drawing that will be made with the same color.

Each Model Is a Problem

This is a basic matter. Each model presents a different problem. It must be observed carefully and its important points and measurements established.

The Sketch

The sketch is made using the same medium that will be used for the project. We will use charcoal if that is what we are going to use for the drawing. Sanguine works well for making sketches, and colored chalk is also useful for sketching. The first step in sketching the model is to make some basic lines on paper. We begin to give form to the subject by taking the important measurements, in the way we explained. The lines should always be sketched lightly, so they can be easily erased if we need to correct something.

a

Important Points

Once the measurement to which the others will be related is established, we must decide on the starting point. Then, by marking horizontal and vertical distances, important new points are located. This continues until enough related points are established by making the master lines of the sketch.

It is important to keep checking that the relationships between the located points are correct and to verify that they are aligned.

An Accurate Drawing

It is essential to correct the sketch as many times as needed if we want the representation to be realistic. Therefore, once the important points are connected, we measure to verify that there are no mistakes. The whole process must be checked. This will be more effective if additional important points are located, different from the previous ones.

Learning by Correcting

All first attempts have their difficulties. If we want to learn to draw we must realize that this is achieved only with practice. We must get in the habit of measuring the correct way and to be exact with the drawing. But if the results are not correct, we will also learn by understanding where the error originated.

Shading and Coloring

Recommendation

When shading or coloring, we begin with the master lines of the sketch. These lines and the visualization of the tonal areas are boundaries that should not be crossed. Besides, it is necessary to respect the corresponding tone.

When the sketch has been laid down, shading with charcoal or coloring with sanguine or chalk follows. Our guide will be the tonal values. In this process, we must practice the way we create tones, always trying to respect the edges of the tonal areas.

Practicing with the Tonal Range

Before we begin, it can be very useful to practice by applying the tonal range on a piece of the same kind of paper that will be used for the project. When we begin to work with charcoal, sanguine, or chalk on the final paper, we should always begin by applying light pressure, which we can gradually increase, following the lines of the sketch.

With or Without Lines?

At the beginning, it is preferable to begin shading or coloring without lines. With some practice one can understand, if not master, the tonal value. Once the habit of relating and establishing tonal values has been learned, it is easier to work with lines.

Gradations

We have seen the usefulness of the system of tonal values. Thanks to it we understand that all the tonal values are related to each other. This relationship is more difficult to maintain when we do not start with isolated tones but resort directly to gradation.

A series of tonal values arranged in order can be represented through a gradation. It is the ideal technique that avoids gaps in tones, and consequently, harshness in the representations.

With practice we will gain experience making gradations without losing sight of the overall relationships between all the tones.

When we shade or color with lines, we begin with a first layer that covers all the tonal areas, except the lightest ones, which are left blank. The next application is, in this case, a series of lines that go in a direction different from the first. The white of the paper and the next lightest areas are avoided. The next application, which consists of another series of lines different from the previous ones, leaves the areas reserved for the three lightest tones blank. Any more hatch lines are applied following the same process.

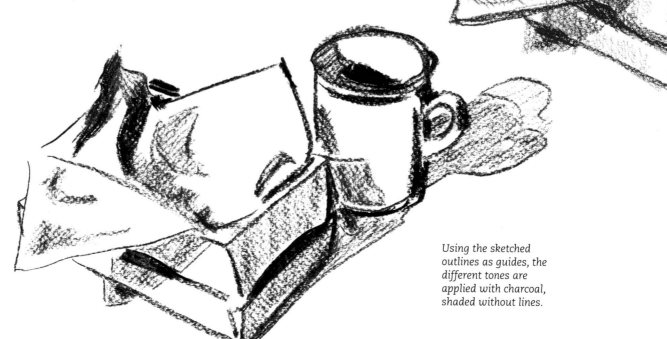

Charcoal, Sanguine Crayon, and Chalk

PRACTICE

Shading and Coloring

Using the sketched outlines as guides, the different tones are applied with charcoal, shaded without lines.

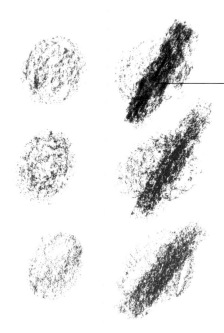

Finding the Value

When the tone applied for shading or coloring is not the desired one, it can be corrected only by blending or erasing the surface. Since this procedure limits the paper's adherence capability, it is better to apply the layers a little more lightly than needed. From this point, it is always possible to achieve the desired tone gradually, by adding layers.

Light shading or coloring can always be darkened with another layer.

Shading or Coloring with Lines

With this technique, and always testing first on a piece of scrap paper, different lines can be tried and the effects of their repetition observed. The lightest tone is the white of the paper. The lightest tone made with lines would be applied to the rest of the paper, and it would represent either the lowest layer of hatching or the next lightest tonal area. A darker tone would be created by adding another layer of lines to the first one or by increasing its density, and so on.

The Lightest Area

The highlighted areas, as well as those that are well lit, always must be kept free of charcoal, sanguine, or chalk. However, if we make a mistake we can reestablish them partially by using an eraser, preferably one that is kneadable.

This drawing done with chalk is an example of how light this medium can be.

The Darkest Areas

The darkest areas, which correspond to the darkest tone of the tonal value system, must also be treated with special care. The tone should not be touched once it has been applied and proper tone has been achieved. This way we will not limit the ability of the paper to hold more pigment, which makes it impossible to darken the tone no matter how we try. A coat of fixative can be used to make it easier to continue darkening the tone, but the final result may not be as clean.

PRACTICAL ADVICE

Clean Edges

When a lighter area is invaded by a darker tone, the drawing or the light of the picture is marred. This can cause the representations of volumes to be distorted. The most practical way to prevent these intrusions is to mentally reserve the space and to abstain from shading it or coloring it. If we are in doubt we can use a finger, the hand, or a template made of paper or cardboard.

1. *The area reserved can be protected with a paper or cardboard template.*

2. *The most practical way is to be careful or to use a finger as a guide.*

Blending and

Fine-Tuning

Blending and rubbing are considered fine-tuning. These actions, when not abused, allow us to reduce contrast by eliminating abrupt gaps, or by decreasing excessive intensity.

By shading or coloring with gradations, we are able to make an approximate representation of the volume of an object. But this can be expressed even better through blending or rubbing. The goal is to soften tonal progression to express the volume without abrupt gaps and harshness.

Blending or Rubbing

Any application that is used to shade or color can be retouched later, through the action of blending or rubbing. We do this whenever we wish to fine-tune a tone or a gradation. The purpose of blending is to lighten the tone by removing charcoal, sanguine, or chalk. Rubbing is used mainly to avoid an abrupt change from one tone to another by creating an intermediate tone that limits such effect. It is easy to understand the use of these techniques, because they are employed to create an accurate overall tonal value in the drawing.

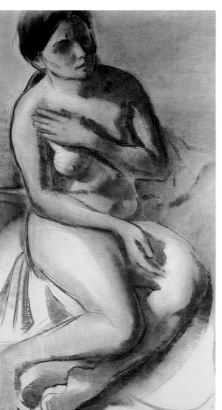

This charcoal drawing by Francesc Crespo shows the artist's use of light and shadow.

This is the effect achieved by rubbing or blending. The direction of the rubbing is inspired by the shapes of the object or sometimes by the direction of the light itself. It is like molding, that is, shaping something, basically using the thumb, and middle and index fingers.

Charcoal, Sanguine Crayon, and Chalk

PRACTICE

Blending and Rubbing in Practice

The Direction

Every stroke must be made in the appropriate direction. It is not enough to just fine-tune a line, or a shaded or colored area; we must do it by rubbing or blending in the right direction. This is why it is important to begin with actual models. By simply observing them we can analyze and synthesize the gesture needed to produce the desired effect.

The direction of the blend is directly related to the lighter or darker effect that one wishes to obtain, and must be related to the overall value. The direction of the rubbing is also very important. It is generally perpendicular to the direction of a gradation, although it is sometimes necessary to blend following curves and circular shapes to express the volume of objects with those shapes.

Rubbing In Practice

Intensity

The overall intensity of the work depends on the darkest tonal value laid down at the beginning. Some artists usually work with lighter tones, whereas others prefer to make darker works. They are all correct, as long as the value system is correct. It is a matter of sensibility. In any case, the intensity of the retouching depends on the value scale that was chosen. When blending, we can apply more or less rubbing pressure on the powder. We can practice on a piece of scrap paper and observe the effect produced by different pressures. With practice, we will be able to apply the correct intensity to create the desired overall tone.

An area can be heavily or lightly worked, by rubbing repeatedly or by barely touching the area where the two tonal values meet. With a little practice, we will be able to control the effects of rubbing.

Another Tonal Range

By blending and rubbing, another tonal range appears, which complements the tonal values that have been created with the applications of charcoal or color that have not been touched. These tonal values can be considered intermediate. Besides, the surfaces covered by blending or rubbing look very different from the untouched shading, color, and lines. It is a different texture.

When we touch the chalk, we notice how easily the powder particles smear. They lie one on top of the other in such a way that the blending or rubbing can create a high-quality chiaroscuro of great tonal richness.

We use the blending stump to continue working over the sanguine lines. This way we blend some areas, which allows us to cover the white in between the hatch lines with a very light sanguine color, while also rubbing the sanguine in the darker areas. We can use the same blending stump, with the sanguine that remains adhered to it, for shading the white paper where desired.

● PRACTICAL ADVICE ●

Using the Hand to Blend and Rub

The hand is the tool we use most frequently when we work with charcoal, sanguine, or colored chalk. We can blend or rub small areas with the tip of the side of the finger. The thumb is most appropriate for curves or circular shapes. With large formats we use other parts of the hand. The palm, for example, can be used to cover larger areas. And finally, the palm and an extended thumb can be used for wiping even larger areas.

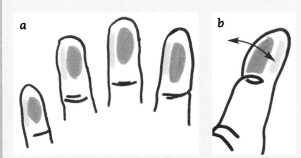

a. The tip or side of any finger can be used.

b. Thanks to the joint of the thumb, it is possible to make circular motions with great ease.

When Corrections Are Nesessary

Even a fine retouching, such as reducing tonal intensity, can be considered a correction. Only simple rubbing may be needed to achieve it. But some mistakes require a more energetic correction.

Blend First

To correct, first the charcoal or color must be removed. We will be able to do a cleaner job on a dark area if we use a fan brush and then finish the job with a clean cotton cloth, even though this is the implement usually used for applying light gradations.

The joint of the thumb helps us blend the cylindrical shape of the vase.

Charcoal is the most volatile of all media; therefore, it is worked more delicately. When we blend, as here using a finger, very little pressure should be applied, because it is easy to reduce the intensity too much.

The Kneaded Eraser

When blending is not enough to make the correction, we must move on to erasing. The properties of an eraser, especially the kneaded type, are required to make the traces of charcoal or color disappear.

The kneaded eraser is a soft material that can be molded into any shape that is required. Furthermore, its unique composition adheres to charcoal or color powder that comes loose.

Bringing Back the Color of the Paper

To bring back the color of the paper, all traces of charcoal or color must be erased. As explained before, this is possible only when correcting light layers. In all of the other cases, more or fewer light traces will always be left from the correction, even after erasing.

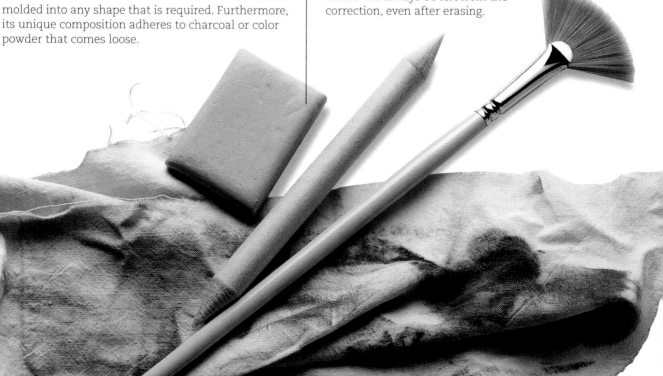

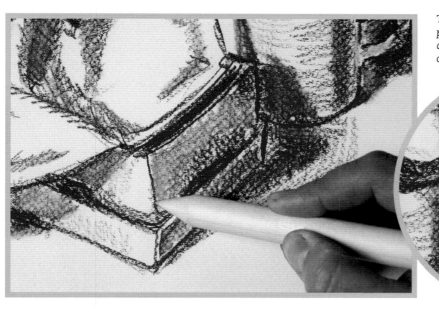

This blending stump in the shape of a pencil makes it easier to work on linear details, using either its point or one side of the conical tip.

The kneaded eraser allows us to restore very light areas, by making highlights. When it is new, the edges are used to work on details and small areas.

Many tools can be used when working with chalk. A square-tip brush, for example, allows us to blend all the linear details. But gradations are of higher quality if they are made with soft circular or zigzag touches.

The Value of White

Among the tonal values, white is the lightest tone and a very important reference point. We should try to leave the white paper clean of charcoal or color to represent this value in the required areas.

Creating a Highlight

When the color of the paper is restored in the middle of a drawing done with charcoal, sanguine, or chalk, it is called creating a highlight.

A piece can be cut from a kneaded eraser, and molded to create the appropriate shape for the surface that one wishes to highlight.

How to Make a Correction

It is impossible not to have to correct or erase to restore some white areas, especially at the beginning. We proceed by paying careful attention to the edges of this "white" area. With the kneaded eraser, we create the white as if we were drawing, but while controlling the back-and-forth movements of the eraser.

A Last Look

The last step of any project consists of taking a look at the whole. This is when we check to see whether the intensity of each tonal area agrees with the vision that we have of the model. This is when the final retouching of the values occurs, the most important being the restoration of the whites.

PRACTICAL ADVICE

How to Prevent Accidental Erasures

When working with such volatile media as sanguine or chalk—and especially charcoal—accidental erasures or blending must be prevented. The best way to avoid this is to develop good work habits.

1. Always use a board larger than the paper. When drawing vigorously, the work should be kept in place by holding the board. If at any time we see that holding the paper is necessary, we should first make sure that our fingers are clean, and then hold it by the white margin left around the piece.

2. The other hand, the one used for drawing, shading, or coloring, must never be in direct contact with the paper. The point of contact is the stick of charcoal, sanguine, or chalk.

3. It is preferable not to wear clothing with wide sleeves that can accidentally drag over the work. If we use a painter's smock, it is best to roll up the sleeves or to button the cuffs.

Charcoal on Colored Paper

Charcoal also works well when used with colored paper. The color can be any that contrasts well with the black charcoal. Furthermore, we can add white chalk to the charcoal when working with colored paper.

Choosing the Color of the Paper

We have several options when choosing the color of the paper. The dominant color of the subject matter we are working with can inspire us. For example, a sunset could suggest to us the use of an orange paper; a nude and the color of the skin could cause us to choose an ochre, pink, salmon, or beige; for a seascape a light blue color could be used, like a sky blue, and so on. But we can also opt for drama and consider using a paper that has nothing to do with the subject, that will effect a great contrast, in itself quite attractive.

Colored Paper

There is a wide range of colored papers on the market. Among these is a large selection of special papers for pastels from which to choose. Any color that contrasts with the charcoal will allow us to create an attractive drawing.

a. Charcoal shading is shown on yellow paper. The texture of the paper can be seen through the shading, with or without the crosshatching.

b. We can experiment with the contrast produced by shading with charcoal on a smooth blue paper.

c. A paper with a light tan color can be a very elegant choice to contrast with the unique black of the charcoal.

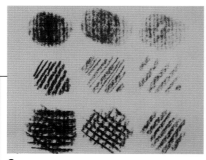

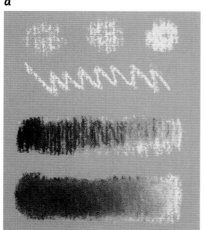

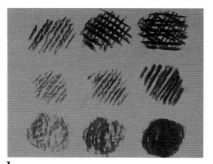

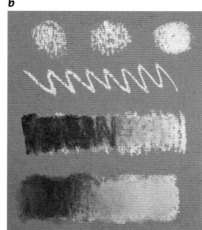

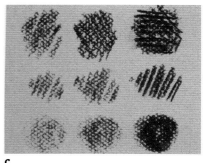

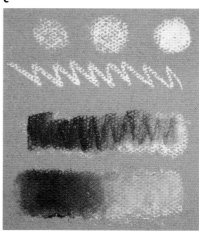

Charcoal and Colored Paper

We produce a tonal range on colored paper. We can observe the effect created on different colored paper. With lighter layers, the color of the paper can be seen through the shading, whereas with stronger applications, all the paper's color is completely covered.

Blending and rubbing with charcoal on colored paper, although technically done the same way as on white paper, produce different effects, which are the result of the combination of the applications of charcoal and the particular color of the paper.

When we practice on yellow, blue, or beige paper with white chalk, a tonal range can be created. With charcoal and white chalk we can also create a gradation. To do this, we superimpose a layer of both. The white chalk is applied hard at first, and then pressure is decreased gradually. Charcoal is applied over the white chalk, but charcoal is lighter where chalk is more intense, and vice versa. It is also possible to rub a gradation between charcoal and white chalk. The result will be a delicate mixture of tones and texture. Also, blending or rubbing charcoal on colored paper produces very interesting effects.

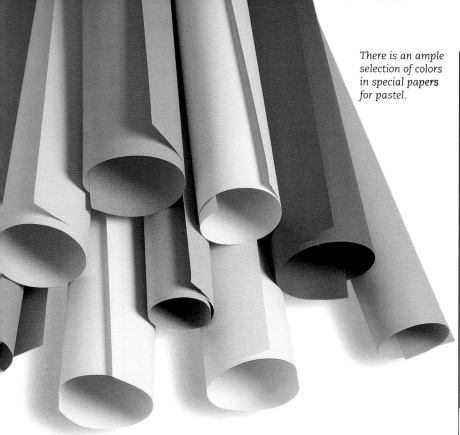

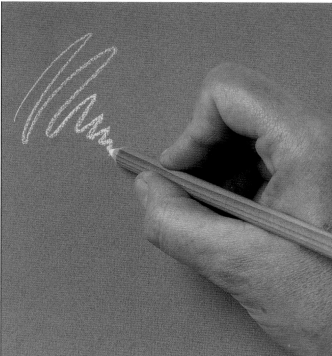

There is an ample selection of colors in special papers for pastel.

Colored paper must be used for the white chalk to be visible when applied directly on it.

Using Charcoal and White Chalk

How do charcoal and white chalk interact? Different charcoal tones are produced when white chalk is added. But both the blending and rubbing that we produce using the two media represent a quality and characteristics that are worth keeping in mind.

• Applying chalk first and then charcoal is not the same as the other way around. The order alters the result.

• Charcoal and white chalk do not have the same degree of volatility. We must practice to get used to their interaction.

• When white chalk is added to charcoal, the layer acquires more consistency. The charcoal powder adheres better when it blends with the chalk.

• The quality achieved when blending or rubbing depends on the direction of their application. Simply color an area in white and another one next to it with charcoal. Blending them from right to left does not look the same as when it is done the other way around.

• To make a gradation with charcoal and white chalk, we first lay down the charcoal from left to right, gradually applying less pressure. Then we shade this area with charcoal, but this time, in such a way that the maximum pressure of charcoal corresponds to the minimum pressure of chalk, and vice versa.

• The range obtained from charcoal and white chalk is a tonal range of grays. First, we must practice placing the charcoal below and then reverse the order. It will be interesting to organize all the values that can be created.

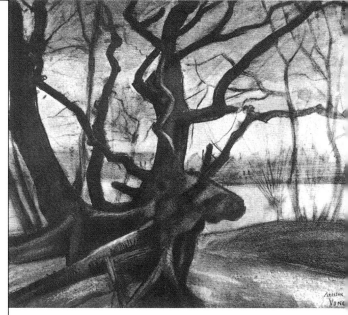

Charcoal pencil has been used on light colored paper with white chalk highlights. Van Gogh, Tree Study.

A teakettle on colored paper produces remarkable effects by using only charcoal and white chalk.

Charcoal and White Chalk

White chalk can be used on colored paper. It will help us create many grays when mixed with charcoal. White chalk also allows us to produce several tones of the color of the paper. Even charcoal alone produces a tonal range. We can experiment with three ranges and increase the possibilities for narrowing down the tonal value system.

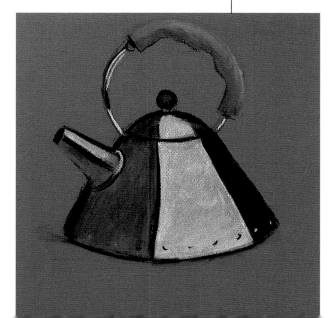

Color on Colored Paper

When we draw with sanguine we can also used colored paper that will contrast with it, whether we are working only with sanguine or also adding white chalk. We have the possibility of creating a good chiaroscuro by using a colored chalk and an appropriately colored paper, especially if the work is enriched with white chalk.

Sanguine Crayon and the Color of the Paper

As long as the color of the paper contrasts sufficiently with the sanguine for it to be seen, anything goes. It is better to begin with a light tone, but more daring choices, which can be made as we gain experience, are also the ones that produce a greater visual impact.

Other Colored Crayons

If we use several colors of sanguine, we can create a work with a range of earth colors, playing with ochre and sepia in addition to the classic iron oxide. Now it is no longer a monochromatic work. It is important to practice with the combinations that can be obtained. There are several options: two colors, two colors and white, even three colors, with or without white. In any case, it is about creating a relationship between all of the combinations, from the lightest to the darkest. The tonal values are enriched by using more color.

Sanguine Crayon and White Chalk

Ranges. When we are manipulating sanguine and white chalk together on an appropriately colored paper, we can create several tonal ranges. In the first place, we have the range of the sanguine applied to the paper; in the second, the range created with the white chalk on the colored paper. But we can also create a tonal range based on mixing the two.

Blending or Rubbing. Both media have a similar volatility, so that the effects of dragging one over the other are similar. When we work with sanguine and white chalk together we should remember that
- the order in which they are applied can change the results;
- based on the direction of the blending, we can obtain lighter or darker overall results;
- even when rubbing small areas, the intention should be evident in a well-defined direction.

We can make a sample showing combinations of the ochre, sepia, and iron oxide to see the results of each color as well as the effects of blending oxide colors on the colored paper.

The World of Color

We should work at cultivating our color sensibility. Although a colored chalk allows us to develop only a tonal range, the use of colored paper causes the system to become more complex. The simple act of choosing an appropriate colored paper—in other words, analyzing the selection of colors offered by paper manufacturers and the possible combinations with colored chalk—in itself constitutes an important learning experience.

Charcoal, Sanguine Crayon, and Chalk

PRACTICE

Color on Colored Paper

When using white paper, the white chalk (stick or pencil) can be seen only on top of a layer of another color, in this case over sanguine.

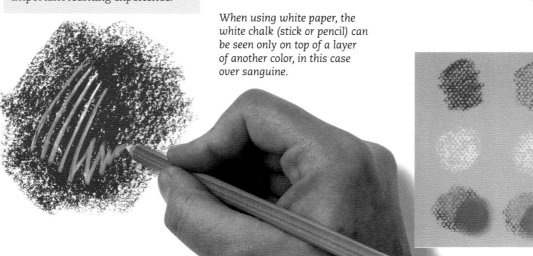

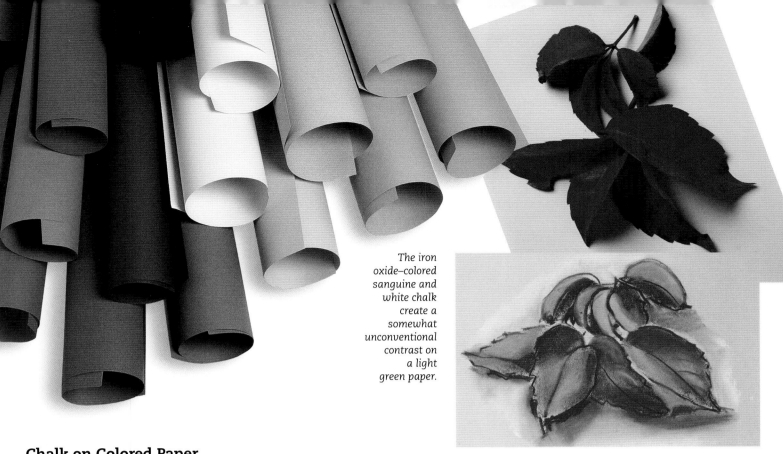

The iron oxide–colored sanguine and white chalk create a somewhat unconventional contrast on a light green paper.

Chalk on Colored Paper

Once the color of the chalk has been selected, the color of the paper must be decided. There are many options. Let's take a look at some of them. As you can see in the example below, a blue colored chalk used together with a white one allows an endless number of possibilities. We can create several ranges: one with the white chalk on the color of the paper, another with the colored chalk on the same paper, and a third mixing both colors on the paper. We can also create gradations of the blue and white chalk, blended and rubbed, where the results will depend on the direction of the application.

We can choose a colored paper based on the dominant blue color of the model. But the same effect is not achieved with a light paper as with a dark one. A blue that is too dark will affect the luminosity of the work. A light blue, on the other hand, will allow us to quickly lay down the general tone. A very light gray would also serve well as a base.

Model

Sketch

It is very useful to make some sketches on scratch paper to study the perspective, in this case parallel or one-point perspective.

On colored paper, sanguine and white chalk used on the same picture allow us to develop many more color and tonal possibilities, as can be seen in these examples made on three different colored papers: salmon, maize, and light gray. On each sample we have:
(above) a range of tones produced by the sanguine on the colored paper;
(middle) a tonal range using white chalk on the colored paper;
(below) another tonal range created by using the sanguine and the white chalk on the colored paper, on which there is also a rubbed circular area.

On light blue paper

On dark blue paper

On very light gray paper

33

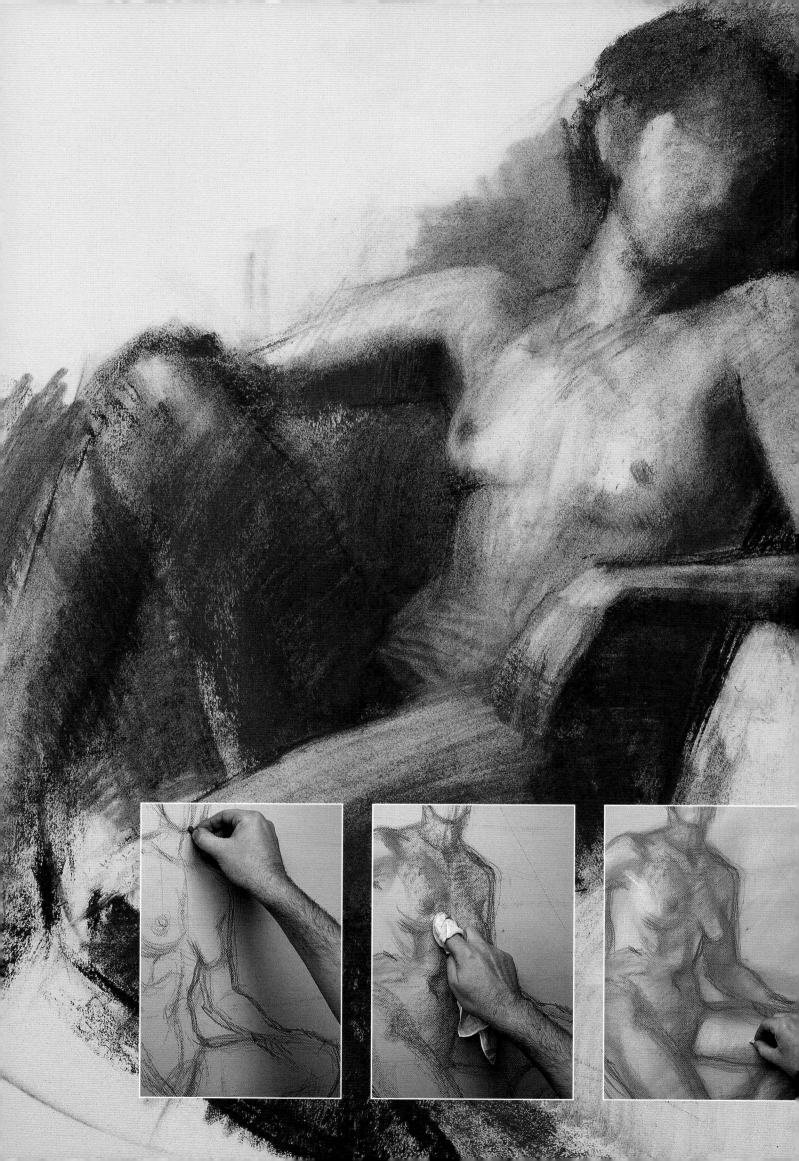

Practical Exercises
Step by Step

To master the techniques of drawing with charcoal and chalk, it is necessary to understand the basic principles and characteristics of the medium, that is, how the drawing materials perform. It is important to practice with enthusiasm and dedication, because drawing skills, like any other skills in art, are acquired only through work and dedication.

The purpose of the exercises presented here is to practice using charcoal and chalk. They have been selected to show you proper working habits and to teach you how to produce particular textures and effects. If you practice the following step-by-step exercises, as you advance in the process, you will acquire a variety of technical abilities that will prepare you for dealing with any subject in these media with complete confidence.

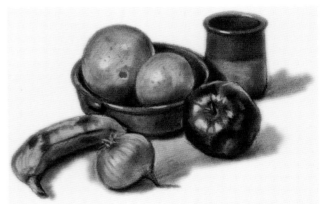

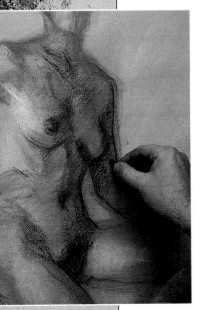

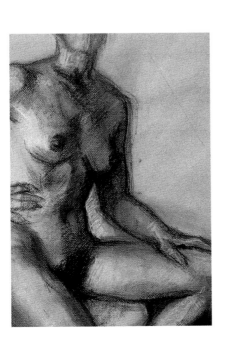

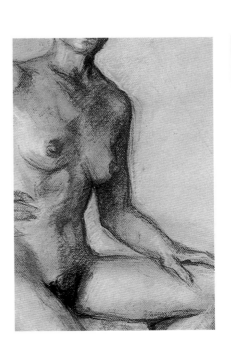

Cloth with Chiaroscuro

MATERIALS

- Charcoal
- Ingres or similar-quality paper
- Rags
- Eraser
- Paper towels

We are going to draw a cloth placed in such a way that the folds create contrasts rich in gradations and tonal values. Learning to work with charcoal begins with this type of exercise, because the way light affects the object is essential for creating the effect of volume. Nowadays, art schools continue to use this type of representation to teach how to differentiate light and shadow effects, and to initiate their students in the technique of shading and modeling with charcoal.

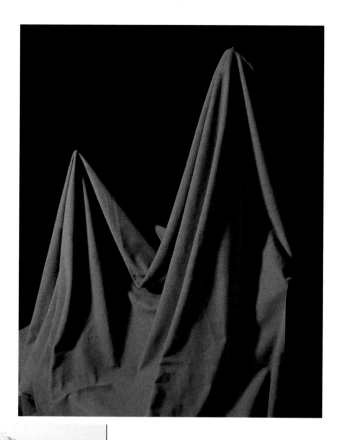

Charcoal, Sanguine Crayon, and Chalk

PRACTICAL
EXERCISES
STEP BY STEP

Cloth with
Chiaroscuro

Step 1

The first step is to determine the shape of the model on the paper. If the charcoal is held as if it were a pencil and only light pressure is applied, it is possible to produce quick lines with the movement of the hand. Treatment should be very loose.

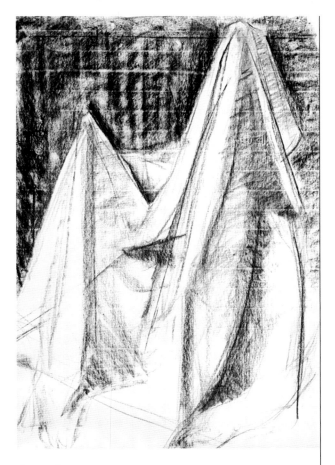

Step 2

After its placement, we make the first tonal value.
To do this, we cover the background with medium gray,
dragging the side of the charcoal stick across the paper.
This same shading will be lighter on the areas of the
cloth.

Step 3

We lightly wipe the surface of
the drawing with a rag to even out
the gray in the areas that require
medium shading, to give the drawing
an atmospheric effect. These are the
intermediate tones on top of which
we will add darker tones.

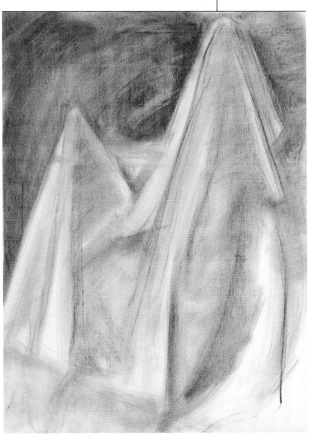

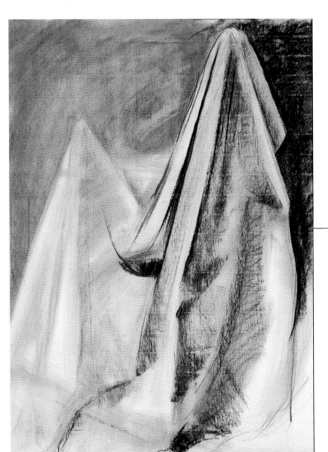

Step 4

We intensify the darks in the folds
over the previously wiped areas of
the cloth, where there is most
contrast. To do this, we use the tip
of the charcoal for the lines and
the gray of the background, and
its side for the intermediate
grays.

Charcoal, Sanguine Crayon, and Chalk

PRACTICAL
EXERCISES
STEP BY STEP

Cloth with
Chiaroscuro

37

Step 5

As the work progresses, it is necessary to alternate the applications of color with blending, using a piece of paper towel to prevent excess charcoal from accumulating on the surface, and to model the gray shading in each area.

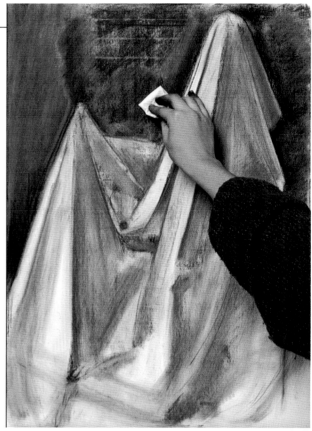

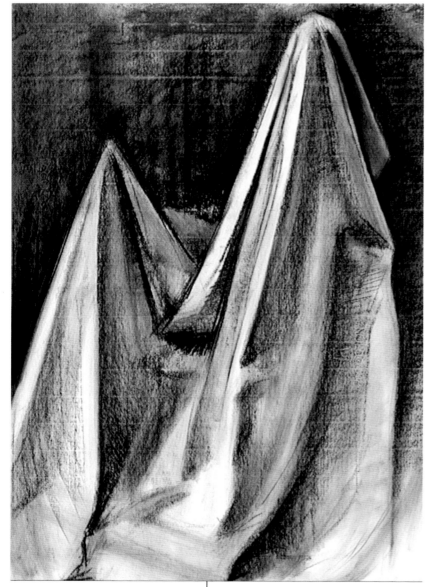

Charcoal, Sanguine Crayon, and Chalk

PRACTICAL
EXERCISES
STEP BY STEP

Cloth with
Chiaroscuro

Step 6

When the background is darkened, the shape of the cloth stands out against it, as well as the lighted areas, whose contrast makes them stand out even more. Shading in the folds must always vary in intensity to produce a great variety of tonal values.

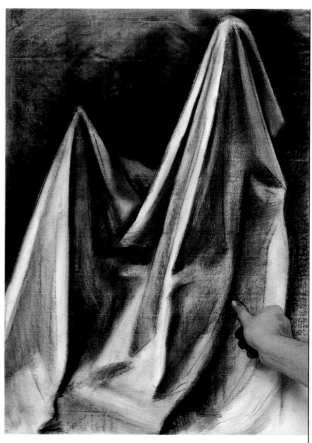

Step 7

The application of new grays and blending with the fingers is almost simultaneous. It is best to blend using circular motions, wrapping and modeling the shape, but without insisting on making the lines of the previous step disappear.

Step 8

The lightest areas of the drawing are cleaned up with an eraser. When the light is sharpened, we enhance the volume effect of the folds of the cloth.

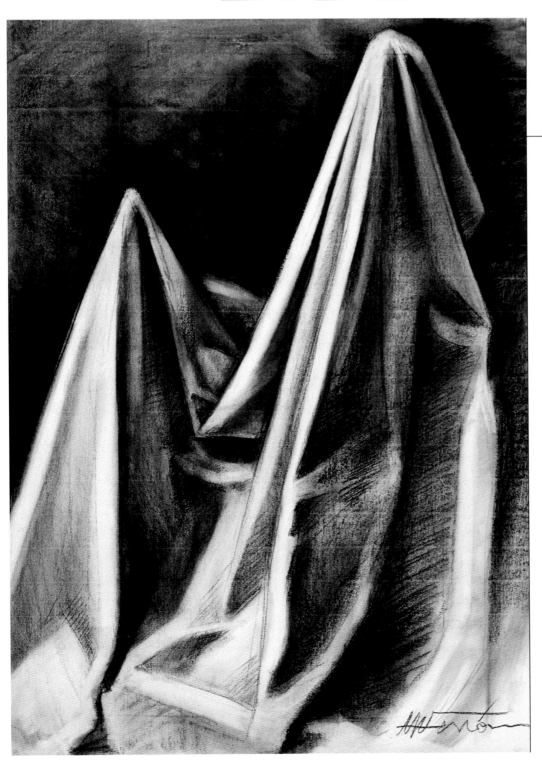

Step 9

With intense and linear strokes, we apply more charcoal to the shaded area of the cloth, enhancing the volume effect of the folds. This step requires much care in the modeling and value of the reflection. At the conclusion of these last steps, our study of a cloth in chiaroscuro is finished.

Charcoal, Sanguine Crayon, and Chalk

PRACTICAL
EXERCISES
STEP BY STEP

Cloth with
Chiaroscuro

Still Life
Based on Geometric Forms

MATERIALS

- Sanguine stick
- Drawing paper, medium texture
- Eraser
- Razor blade

After studying the structure of any object, it is easy to see how it can be drawn within a geometric figure. In fact, all the elements in nature can be seen as simple geometric forms. This means that any person who is able to draw a cube, a sphere, a cylinder, or a pyramid can draw an object based on those shapes. In this exercise we will study how those simple forms fit in and how they evolve to form a specific shape.

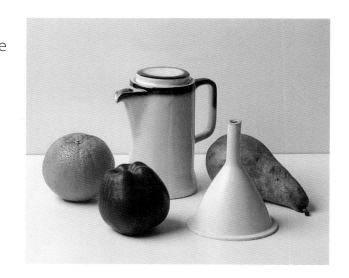

Step 1

It is necessary to establish a relationship between the shape of each element and a simple geometric shape. The preliminary transformation into geometric shapes makes it possible to produce a well-proportioned drawing and is the first step to achieving volume in the still life.

Charcoal, Sanguine Crayon, and Chalk

PRACTICAL
EXERCISES
STEP BY STEP

Still Life
Based on
Geometric
Forms

40

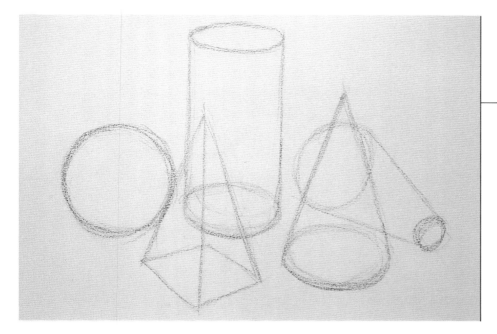

Step 2

In the first layout, the artist has reduced the objects of the composition into four basic geometric shapes: a sphere, a cylinder, a pyramid, and a cone.

Step 3

It is easy to complete this drawing from the sketch of the basic geometric forms. Using the tip of the sanguine crayon, we reinforce the lines that shape each of the elements of the model.

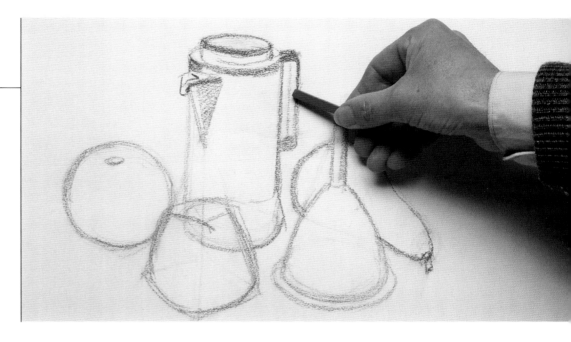

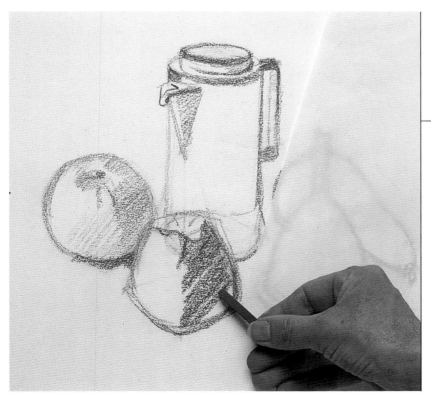

Step 4

With the tip of the sanguine crayon at an angle we shade the main areas. To protect the lines of the still life, we place a piece of tracing paper on top of the drawing on which to rest the hand. This way, we prevent accidental smearing.

Charcoal, Sanguine Crayon, and Chalk

PRACTICAL
EXERCISES
STEP BY STEP

Still Life
Based on
Geometric
Forms

Step 5

The structure of the objects is defined by retracing the outside lines. The first round of shading is done with very soft parallel lines, with the purpose of establishing the main dark areas first, not so much to produce the shading, but to plan the light areas.

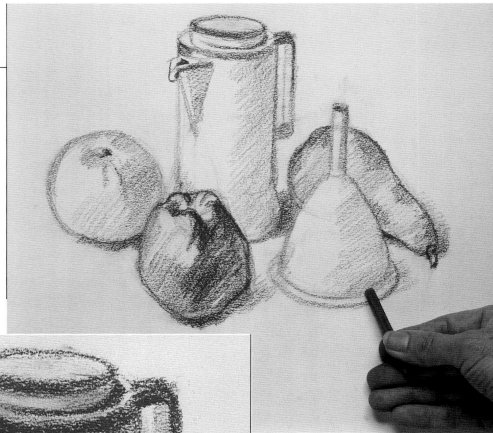

Step 6

The darkest areas of the coffeepot are darkened with successive shading, which makes its cylindrical shape stand out more. Depending on the amount of pressure applied on the paper with the sanguine stick, it is possible to completely cover an entire area of the paper until its texture is saturated.

PRACTICAL
EXERCISES
STEP BY STEP

Still Life
Based on
Geometric
Forms

Step 7

The shading of the apple and the funnel is softened with the tip of the finger. The darkest shading corresponds to the areas of the model that present the darkest tones. Values must be increased gradually.

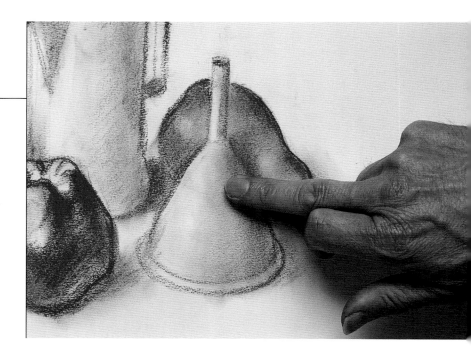

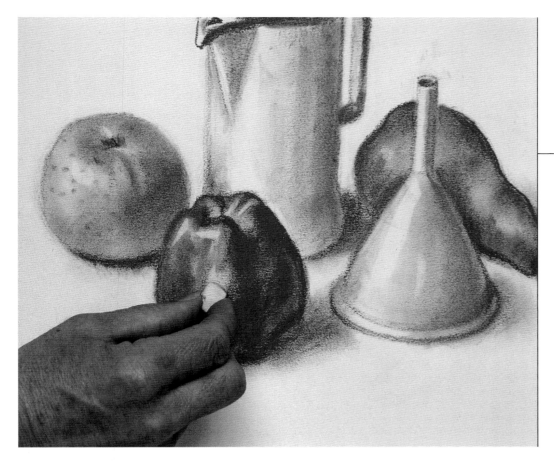

Step 8

Next, the only thing left to do is to create the most important highlights on the funnel, the coffeepot, and the apple with an eraser, because during the shading process they get smeared with the sanguine.

Step 9

After further applications of color, the entire composition is rubbed with a blending pencil to create a more unified and atmospheric effect.

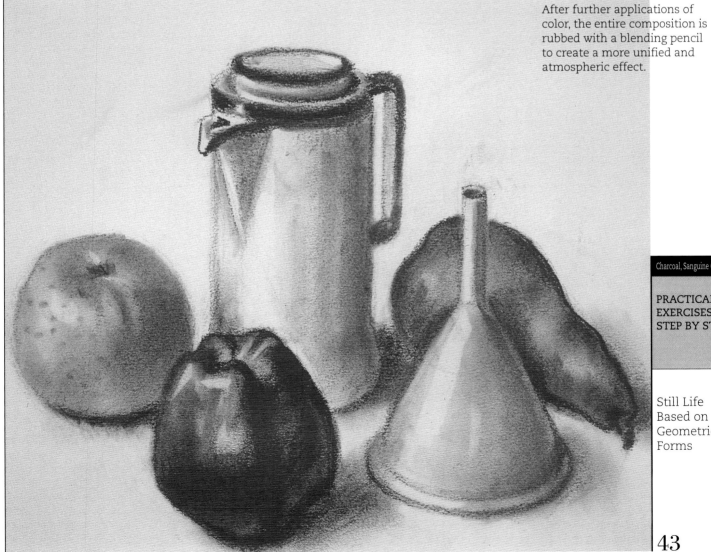

PRACTICAL
EXERCISES
STEP BY STEP

Still Life
Based on
Geometric
Forms

43

Volume Effect in a Still Life

Charcoal

MATERIALS

- Charcoal
- Fine-textured drawing paper
- Razor blade
- Eraser
- Rags

This time we propose an interesting exercise in which we will show the step-by-step process used to apply light and shadow to give volume to the objects. We will see how, starting with a simple arrangement and the application of various gradations of shadow and erased areas, a complete still life of glass objects can be achieved. As you will see, the effects produced by using an eraser are so useful that it becomes a perfect complement for drawing with charcoal.

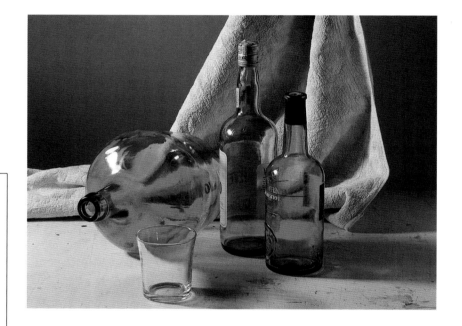

Step 1

We begin by drawing one vertical and one horizontal line, the symmetrical axes needed to balance the composition correctly. The first step of the process should be to consider the overall shape, and then the different elements and their proportions.

Charcoal, Sanguine Crayon, and Chalk

PRACTICAL
EXERCISES
STEP BY STEP

Volume Effect
in a Still Life

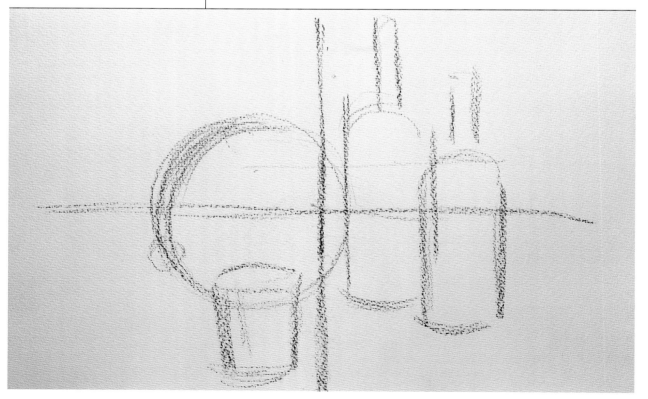

Step 2

Next, we draw the outline of each one of the objects with more precision, using the tip of the charcoal and the previous sketch as a guide.

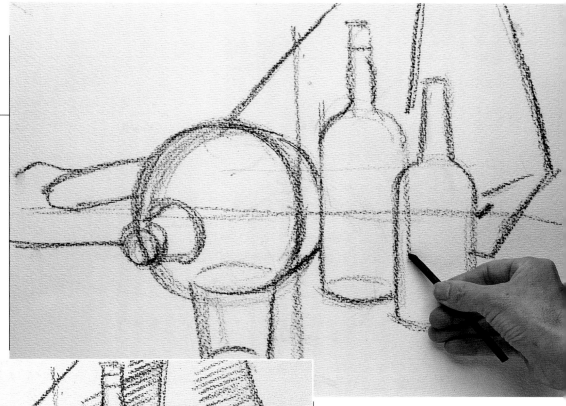

Step 3

Although it is better to use the tip of the charcoal for the outlines, we will use the side of the stick for this step. As we apply the first shading, we blend it with the tip of our finger until the first gradations of color are achieved.

Step 4

The main differences between light and dark areas are established. This is achieved by drawing quick parallel lines with a light pressure on the charcoal.

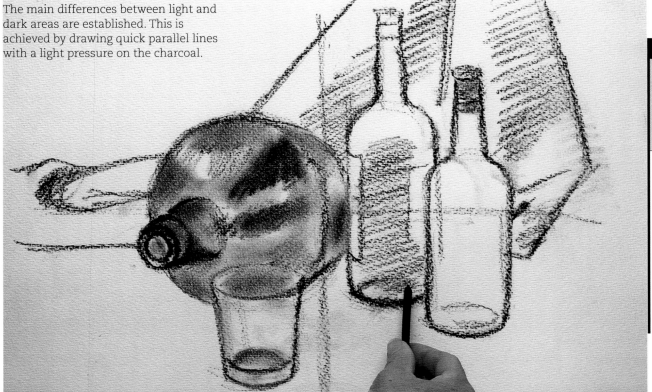

Charcoal, Sanguine Crayon, and Chalk

PRACTICAL
EXERCISES
STEP BY STEP

Volume Effect
in a Still Life

45

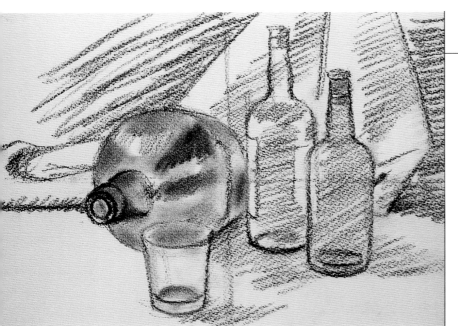

Step 5

The darker tones are produced with wide and loose shading, increasing the intensity in the darkest areas. At this point the tones seem very crude, but we can begin to see the first hints of light.

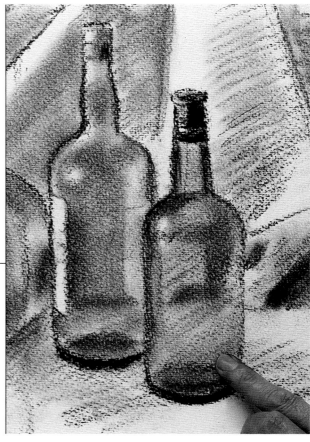

Step 6

We go back to touch up the bottles and to emphasize the outline even more. New values are added to sketch the distribution of light on the glass, leaving small light areas at the base of the bottle neck as a reflection. Each application is blended with a finger, as before.

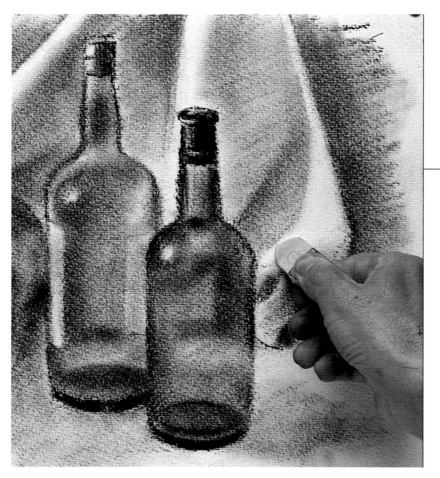

Step 7

The highlighted areas of the bottle and the areas of light in the folds of the background cloth are created with an eraser. Working with charcoal causes the eraser to get dirty easily, so it has to be constantly cleaned by rubbing it on clean paper.

Charcoal, Sanguine Crayon, and Chalk

PRACTICAL
EXERCISES
STEP BY STEP

Volume Effect
in a Still Life

Step 8

The highlighted areas created on the glass are very precise. They follow the curve of the rim of the glass and they are made with the sharp edge of an eraser, produced by cutting off a piece with a blade.

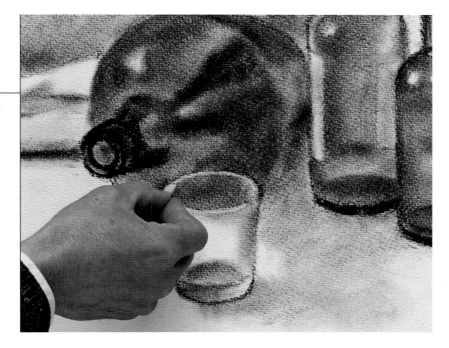

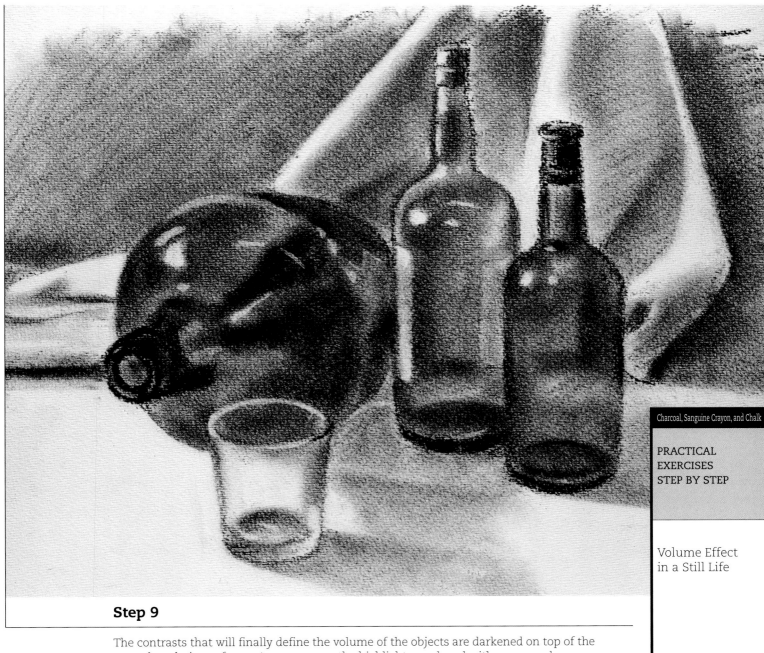

Charcoal, Sanguine Crayon, and Chalk

PRACTICAL
EXERCISES
STEP BY STEP

Volume Effect
in a Still Life

Step 9

The contrasts that will finally define the volume of the objects are darkened on top of the several gradations of tone. As we can see, the highlights produced with an eraser become very precise, much more than if they had been drawn and left untouched, because this would have limited the freedom of the hand to work the rest of the object and would have affected the spontaneity and the freshness of the drawing.

Still Life
with Highlights

MATERIALS

- Charcoal
- Bistre and white chalks
- Fine-textured drawing paper
- Eraser
- Blending stump
- Rags
- Razor blade

Now we will try to draw a still life with bistre chalk and white chalk to make the highlights. This exercise allows us to produce chiaroscuro effects with a dark brown or a bistre chalk, the expression of the light tones with a white chalk, and the intermediate tones with a light blending. As we can see, chalk produces many tones and its technique is similar to charcoal. However, it is more dense and the results have a different look. In many ways, this technique parallels the monochromatic methods.

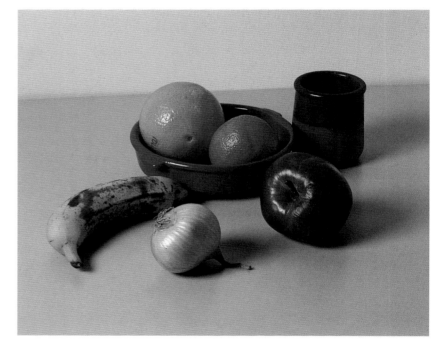

Charcoal, Sanguine Crayon, and Chalk

PRACTICAL
EXERCISES
STEP BY STEP

Still Life with
Highlights

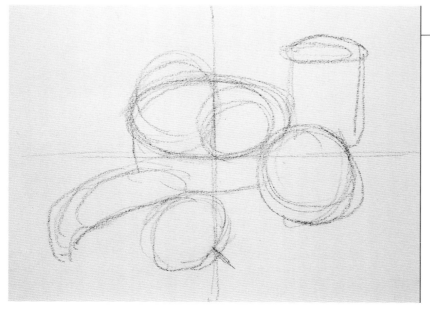

Step 1

After establishing the axis of symmetry, each element of the still life is arranged within the composition. As we can see, the shapes of the fruits and vegetables are represented by circles that have been slightly altered at the top and bottom.

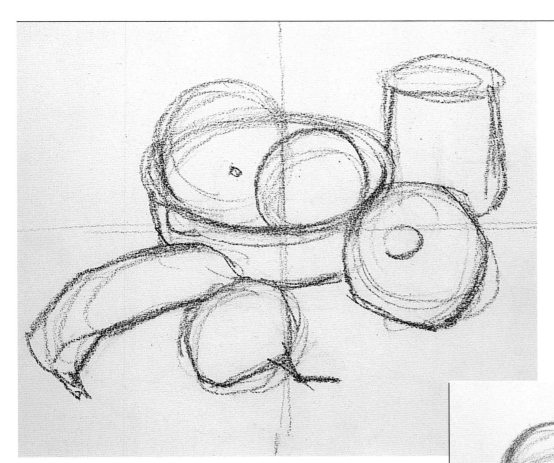

Step 2

Once the grouping has been sketched, the lines are retraced with darker strokes. This way the lines are emphasized and the sketchy preliminary ones are eliminated.

Step 3

We produce the first tonal effects by shading with lines. We begin by darkening the shaded areas with diagonal lines, lightly dragging the charcoal to create a preliminary tonal plan.

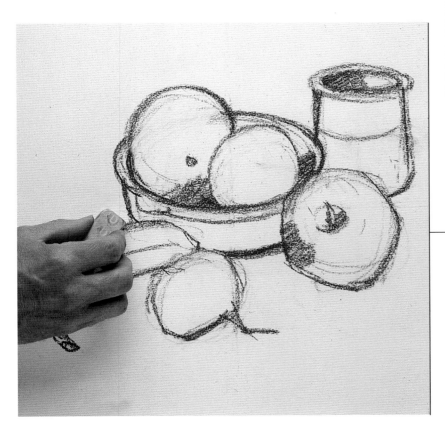

Step 4

An eraser is used to eliminate any marks left by the hand dragging on the surface. The axis of symmetry is eliminated and we draw the shapes of the elements, removing any additional lines that might confuse us.

PRACTICAL
EXERCISES
STEP BY STEP

Still Life with
Highlights

49

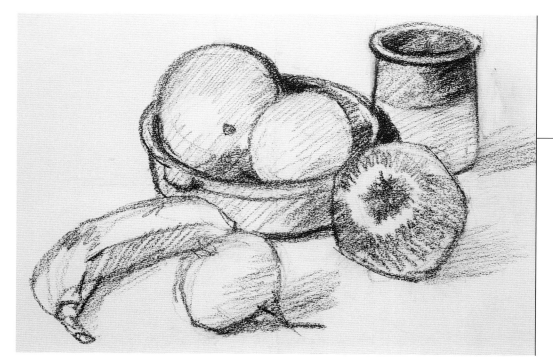

Step 5

In some of the elements, the diagonal shading must be alternated with a more defining line to better suggest the volume of the objects.

Step 6

We blend and model the intermediate tones with our fingers. We should not apply too much pressure while blending to prevent chalk from becoming compacted on the surface of the paper. Softening the contours and the combination of the shape with its shadow are of utmost importance for creating the illusion of solidity in the drawing.

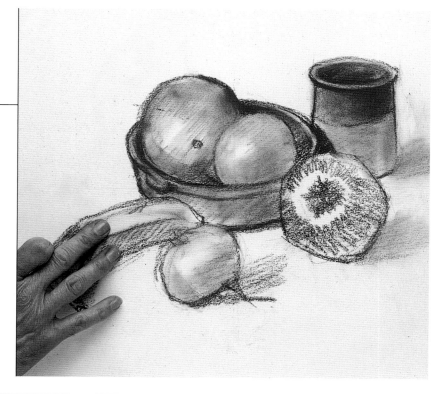

PRACTICAL
EXERCISES
STEP BY STEP

Still Life with
Highlights

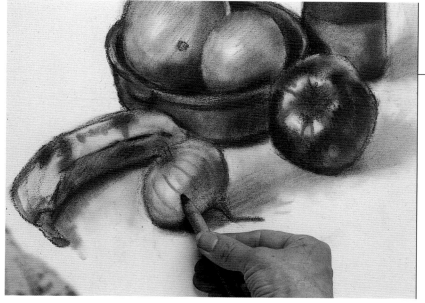

Step 7

The darker areas are shaded again with new lines, which are blended once more with a blending stump. Using this tool makes it possible to reach small areas of the drawing, achieving delicate tonal changes and lines, if required.

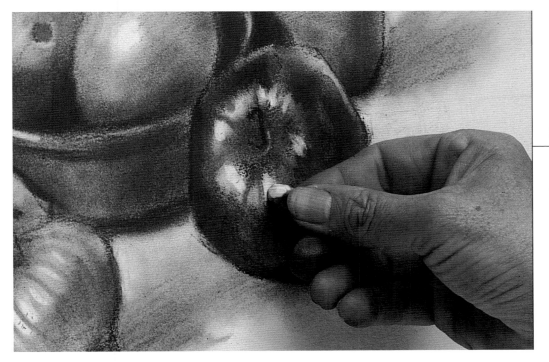

Step 8

Creating highlights with white chalk is the final step of the project. The idea is to use these final touches to make the volume of the objects and the effect of the light stand out, making the composition come to life.

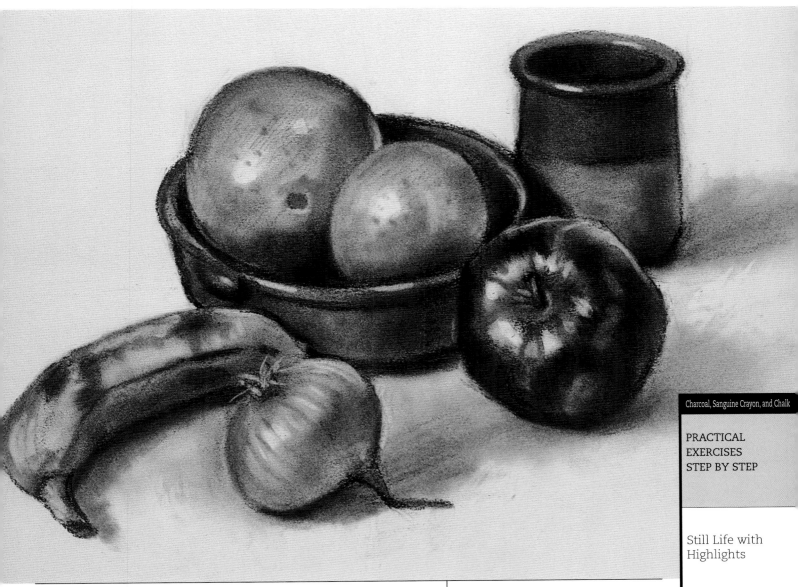

PRACTICAL
EXERCISES
STEP BY STEP

Still Life with
Highlights

Step 9

The lines that define the contour of the objects are emphasized. The successive shading helps to represent the pieces of fruit in terms of volume. The shadows projected by the objects onto the white paper are made by rubbing them with the blending stump. This gives them more physicality.

Still Life
on Medium- Tone Paper

Charcoal

White chalk

MATERIALS

- Charcoal
- White chalk
- Colored drawing paper
- Kneaded eraser
- Rags or paper towels

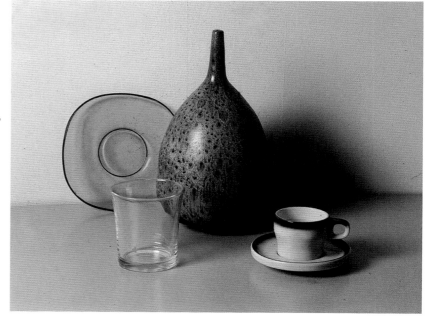

The color and tone of the background obviously affect the final look of the drawing. They present many advantages when it comes to the speed and precision in modeling the shapes, when compared with a white background. They also allow the variations of the lighter tones to be worked more precisely. The study of the light areas using white highlights adds another dimension when drawing the volume of the objects. It is not difficult to combine charcoal and white chalk in the same work, because these materials have similar characteristics that are quite complementary.

Charcoal, Sanguine Crayon, and Chalk

PRACTICAL
EXERCISES
STEP BY STEP

Still Life on
Medium-Tone
Paper

Step 1

The first step consists of arranging all the objects by turning them into basic shapes. For the time being, these figures do not have to resemble the objects that we plan to represent too closely.

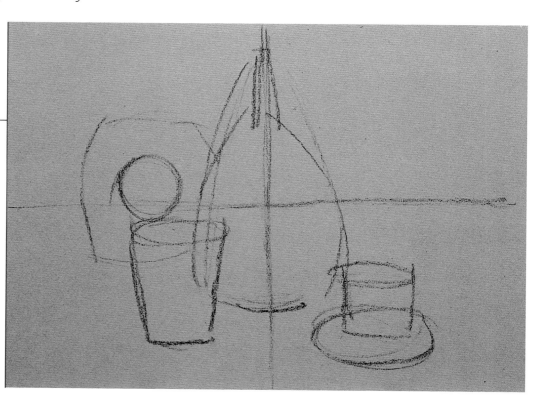

Step 2

We go over the lines of the sketch with more pressure on the tip of the charcoal, emphasizing those that we consider to be defining. We make several quick diagonal and parallel lines on the bottle to represent the shaded areas.

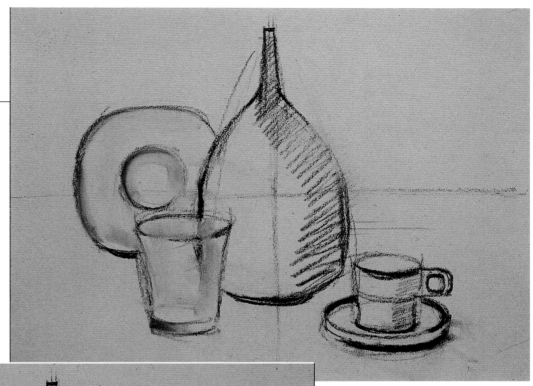

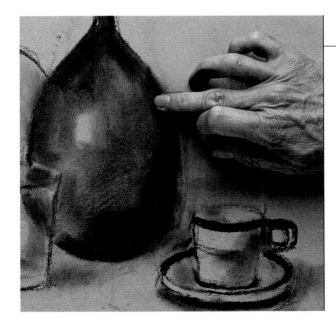

Step 3

With the tip of our finger, we blend the previous shading and model the effect of the light inside the bottle. We leave light areas through which we can see the paper to represent the lighted areas of the glass.

Step 4

Using fingers charged with pigment, we lightly shade the inside of the plate and the side of the glass, and we project the lower shadow of the coffee cup and saucer.

PRACTICAL
EXERCISES
STEP BY STEP

Still Life on
Medium-Tone
Paper

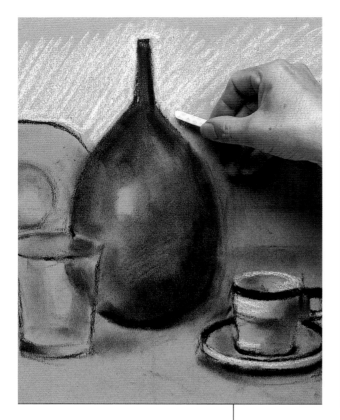

Step 5

Once the overall look of the grouping is established, it is time to introduce the white chalk. First, we shade most of the background with parallel lines, trying not to touch the objects.

Step 6

With a cotton cloth or paper towel, we blend the lines to even out the surface. When we blend and cover the paper completely, the drawing acquires a more atmospheric feeling.

PRACTICAL
EXERCISES
STEP BY STEP

Still Life on
Medium-Tone
Paper

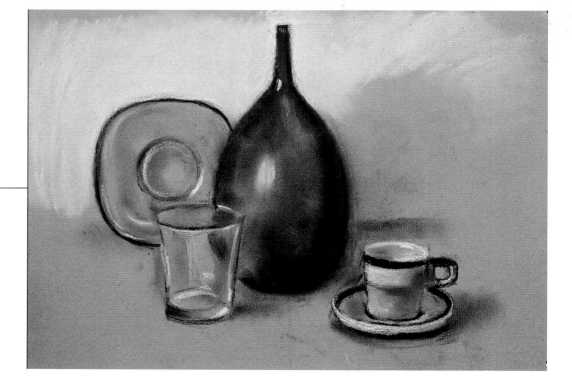

Step 7

The contrasts are heightened in the darker zones by coloring areas with white chalk. Shading is done by simply repeating the blending with our fingers, going over the same area repeatedly.

Step 8

Highlighting is effective when it is not spread evenly through the entire composition, but applied in those areas that help bring out the contrast, therefore maximizing the effect of volume in the composition.

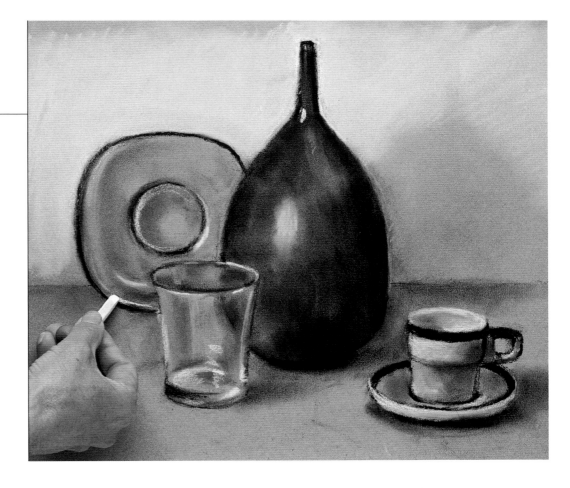

Step 9

In this last step the values of the bottle are revised to heighten the tones. We highlight the edges of the other objects by using white chalk and charcoal alternately. Then, using the tips of our fingers as if they were a brush, we blend these new strokes into the grouping of the coffee cup and saucer and the glass.

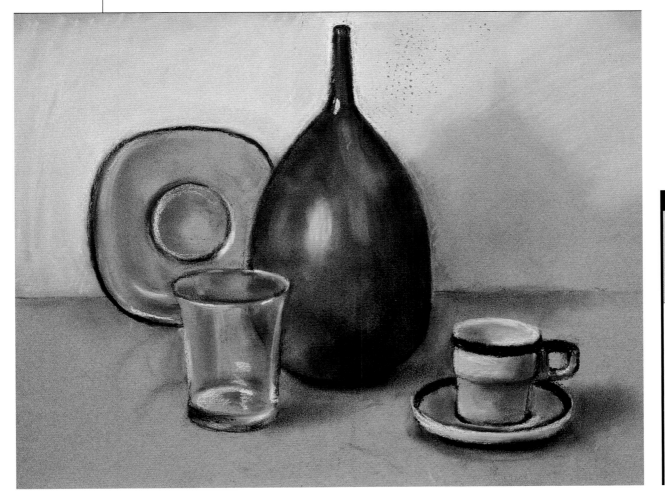

Charcoal, Sanguine Crayon, and Chalk

PRACTICAL
EXERCISES
STEP BY STEP

Still Life on
Medium-Tone
Paper

Sketching with Charcoal

- Charcoal
- Medium-texture drawing paper
- Eraser
- Rags
- Fixative spray

The purpose of this project is to familiarize the amateur with the different possibilities that charcoal offers. We have chosen a landscape with a tree in the foreground because, given the versatility of the landscape in terms of proportions and drawing rules in general, it presents a layout that is easy to resolve. When sketching, the most important thing is to resolve the composition, form, and the most outstanding contrasts, leaving out the unnecessary details.

Step 1

We begin drawing with the side of the charcoal stick. This way, we can use the entire stick for laying down color on the paper. We draw the line of the horizon and the structure of the tree trunks.

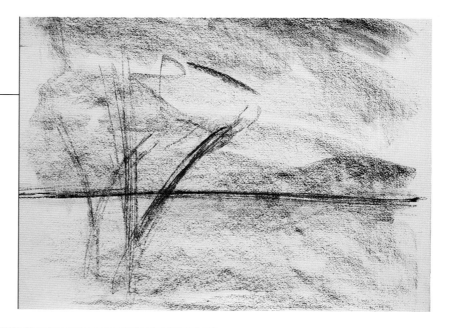

Charcoal, Sanguine Crayon, and Chalk

PRACTICAL
EXERCISES
STEP BY STEP

Sketching
with Charcoal

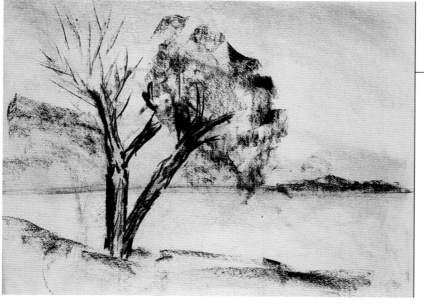

Step 2

The excess charcoal is brushed off and we draw the tree trunks, emphasizing the darker areas. Then right at the top of the outline of the tree we press harder to make a darker gray for the treetop.

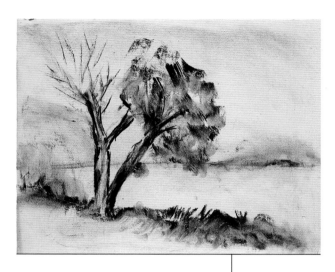

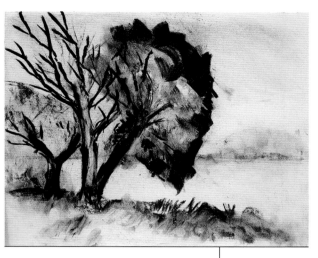

Step 3

We use a piece of charcoal of about 1 inch (3 cm) to define the lower part of the drawing. After applying the charcoal, we blend some areas with the fingertips.

Step 4

In this step, we increase the contrast. The branches of the tree on the left are traced, and we have added volume to the tree on the right by drawing darker shadows for foliage.

Step 5

The interpretation of the tree's texture is achieved with an eraser, which allows us to open up areas to convey light or to make thin branches. We lightly rub a finger along the outline of the tree, extending the color toward the white area of the paper.

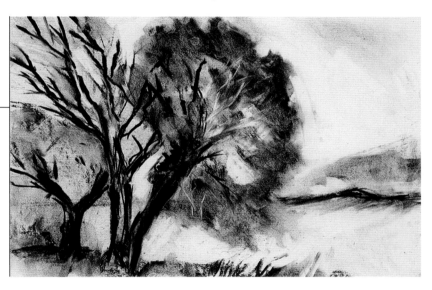

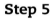

Step 6

We draw some of the tree branches with the tip of the charcoal. Using our fingers as if they were a brush, we wipe the bottom part of the drawing to represent the texture of the vegetation. To finish it, we spray fixative over the surface.

PRACTICAL
EXERCISES
STEP BY STEP

Sketching
with Charcoal

Mediterranean Agave
with Blue Chalk

MATERIALS

- Blue chalk
- Fine-texture drawing paper
- Eraser
- Blending stump
- Rags

In this exercise we will use blue chalk to draw. This drawing medium is less grainy and more compact than charcoal, and produces more intense and darker lines, although it is soft enough for blending with the finger or with a blending stump. We have chosen a coastal plant as a model. The difficulty of this representation consists mainly in drawing the foreshortening of the different leaves and the shading with its corresponding highlights.

Charcoal, Sanguine Crayon, and Chalk

PRACTICAL
EXERCISES
STEP BY STEP

Mediterranean
Agave with
Blue Chalk

Step 1

We mark an axis of symmetry with the chalk, upon which we will begin to sketch the position as well as the approximate shape of each leaf. As you can see, this initial drawing is quite sketchy.

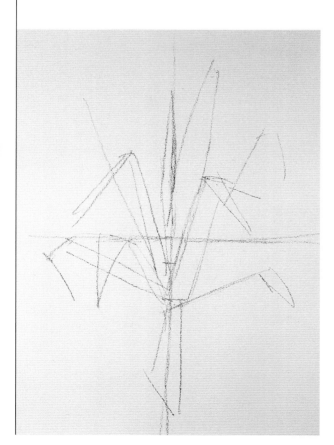

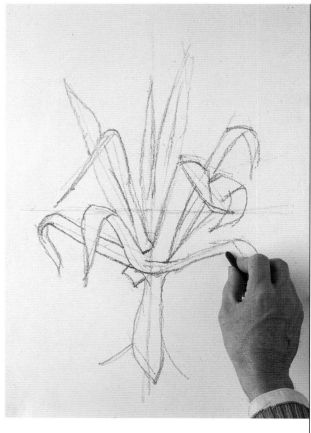

Step 2

We correct the outline of the plant by applying more pressure to the blue chalk. The previous straight lines are turned into curved lines that outline the shape of the plant even more. It is important to pay careful attention to each leaf.

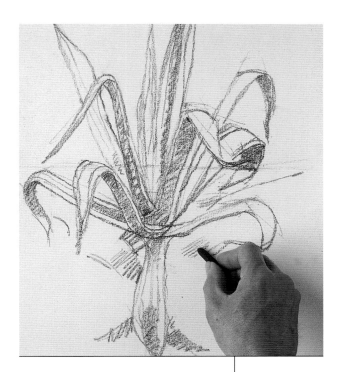

Step 3

A few quick lines are used to define the main shaded areas. We keep the rest of the light areas white, just leaving them be. Clearly differentiating these two areas from the beginning will help us understand the volume of the plant better.

Step 4

We blend the initial gradations with the fingertips, leaving lighter shades or white areas where the light reflects on the leaves. Lightly wiping is enough to eliminate any traces of lines.

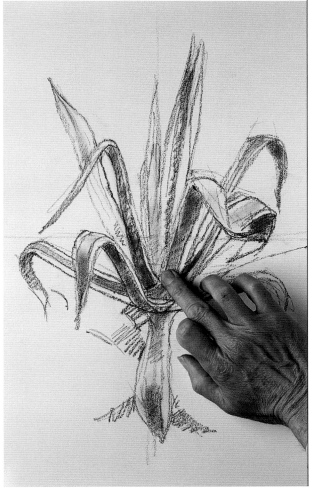

Step 5

We rub in the darker structural lines with the blending stump. This tool permits us to integrate the shapes with soft gradations.

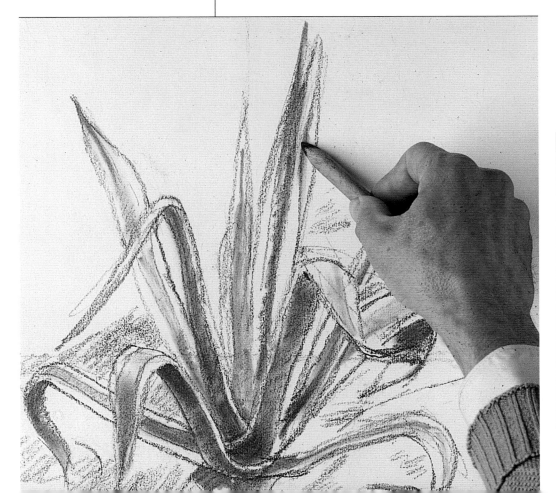

Charcoal, Sanguine Crayon, and Chalk

PRACTICAL
EXERCISES
STEP BY STEP

Mediterranean
Agave with
Blue Chalk

59

Step 6

We apply details to the edges of the leaves with a small piece of a white chalk. Notice how the artist highlights the characteristic serrated edge of the agave's leaves in some areas.

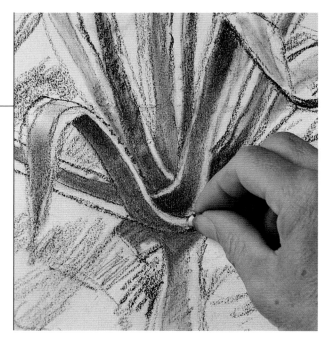

Step 7

We use an eraser to clean the smearing caused by the rubbing of the hand when moving it across the paper. We also touch up the edges to prevent them from looking too blurry.

PRACTICAL
EXERCISES
STEP BY STEP

Mediterranean
Agave with
Blue Chalk

Step 8

We differentiate the areas with more light from the shaded areas with diagonal strokes. The finger is able to blend large areas with great precision. We can combine blended zones with areas of well-defined lines.

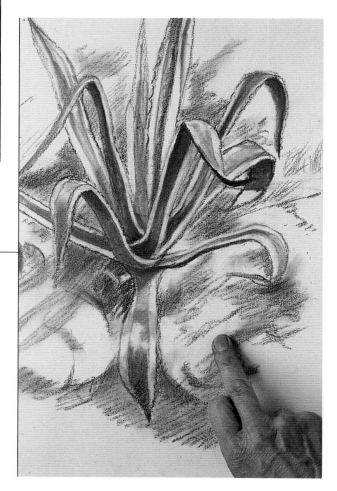

Step 9

We model the reflection of the sun on the rocks, and we highlight areas on the leaves with an eraser. These highlights help convey the soft and velvety texture of the plant.

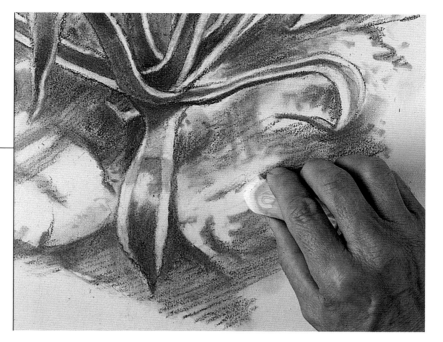

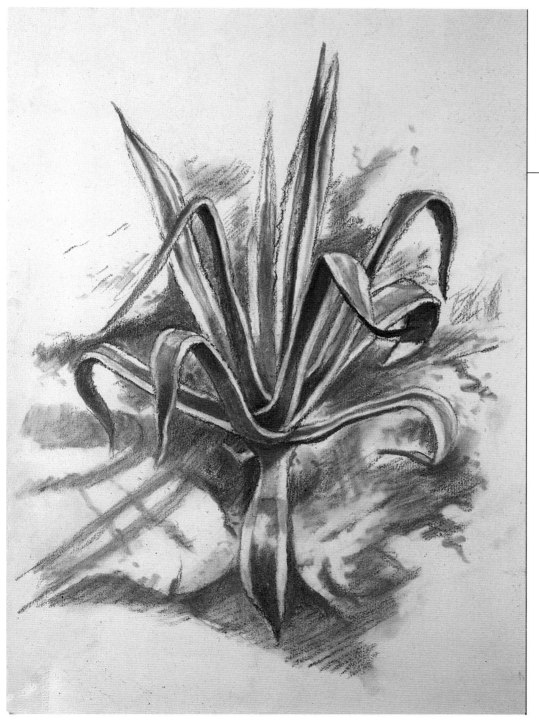

Step 10

To finish up, we increase the contrast of the darker areas with more blue chalk, extending the color softly with a gradual tonal shading toward the lighter areas.

Charcoal, Sanguine Crayon, and Chalk

PRACTICAL
EXERCISES
STEP BY STEP

Mediterranean
Agave with
Blue Chalk

Landscape
at Dusk

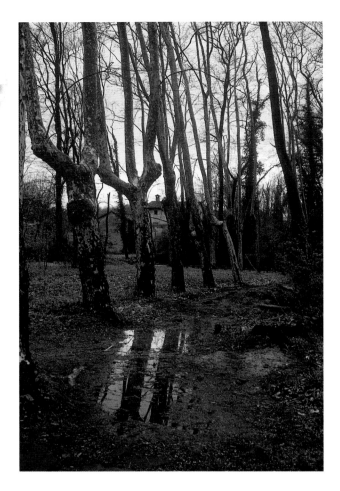

Charcoal

Sanguine

MATERIALS

- Charcoal
- Sanguine
- Blending stump
- Kneaded eraser
- Pencil eraser
- Ingres laid paper
- Rags
- Flat-bristle brush

In the following exercise, we show how to use the principal techniques for drawing a landscape using a simple approach: how to create highlights, textures, and depth. The chosen theme, a forest in the evening, is very attractive. The composition, the fading light, and the reflections are some of the main characteristics of the model.

Step 1

We cover the ground area by shading it with the side of a charcoal stick, revealing the paper. Then, with a finger, we mark the locations of the trees.

Charcoal, Sanguine Crayon, and Chalk

PRACTICAL
EXERCISES
STEP BY STEP

Landscape
at Dusk

62

Step 2

When drawing the tree trunks with the finger, we drag the charcoal particles, which produces a sketch with a certain ghostly look. The branches are drawn by rubbing with fingertips darkened with charcoal.

Step 3

Holding the charcoal stick on its side and vertically we make the first lines on the tree trunks. This way of holding the charcoal stick lets us make a firm and straight line. Strokes of sanguine crayon are added to the lower part of the drawing.

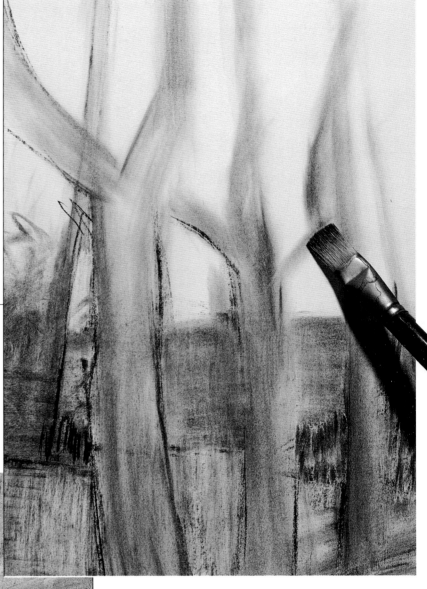

Step 4

The blending done with fingers is complemented with more applications of charcoal powder using a flat-bristle brush. If light pressure is applied, the blend will be very soft.

Step 5

The highlights for the puddles are made with horizontal strokes, using a kneaded eraser. When the eraser gets dirty, it can be kneaded and used again for erasing or linking highlights.

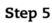

Charcoal, Sanguine Crayon, and Chalk

PRACTICAL
EXERCISES
STEP BY STEP

Landscape
at Dusk

63

Step 6

We complete the tree forms with the brush charged with pigment and with the blending stump. Notice how the highlights made with the eraser add variety by breaking the monotony of the gray shading of the foreground and create a more interesting drawing.

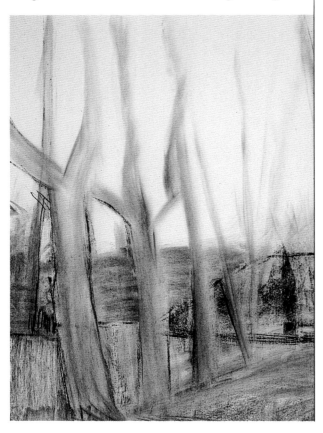

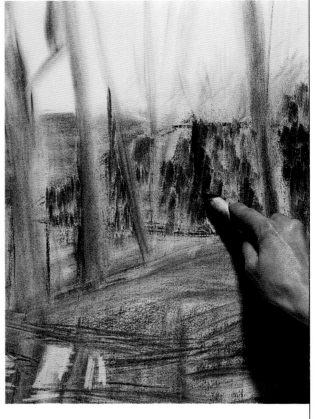

Step 7

Using the tip of the blending stump saturated with charcoal dust we darken the band of vegetation in the background. The tonal applications must be done in the same direction to give texture to the foliage of the trees.

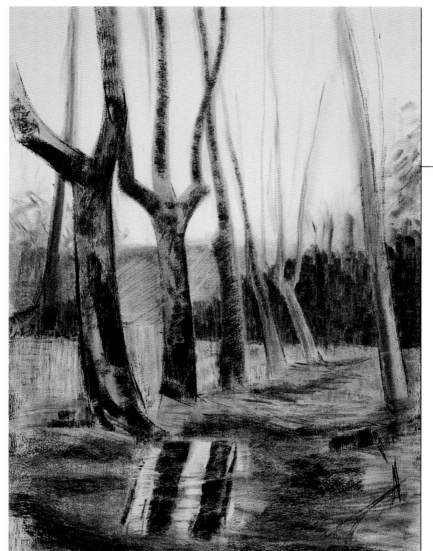

Step 8

The shading done with sanguine and the reflections of the trees on the puddle add more importance to the foreground. We highlight the contrast of the tree trunks with a small piece of charcoal.

Charcoal, Sanguine Crayon, and Chalk

PRACTICAL
EXERCISES
STEP BY STEP

Landscape
at Dusk

Step 9

Diagonal lines made with a pencil eraser create the effect of sun rays flooding the scene. This type of shading can add a sense of movement to a composition that is otherwise static.

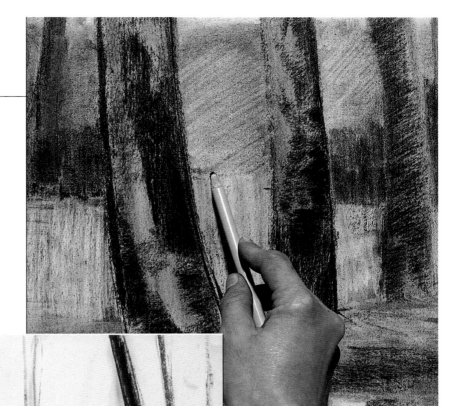

Step 10

We accentuate the foreground with streaks of sanguine. This way we produce a strong sense of depth, because the warmth of the reddish color tends to make the foreground appear closer to the viewer.

Charcoal, Sanguine Crayon, and Chalk

PRACTICAL EXERCISES STEP BY STEP

Landscape at Dusk

Perspective Exercise

Charcoal

Graphite

MATERIALS

- Number 3B graphite pencil
- Charcoal stick
- Charcoal pencil and compressed charcoal stick
- Fine-texture drawing paper
- Eraser
- Plastic ruler

A model of this type requires the application of certain rules for the perspective to be correct. If we observe carefully, we will see that the lines of the model converge at a single point in the middle of the paper. The spaces that the various stands of the market occupy look smaller as they get farther away from the viewer's eye. At the same time, this reduction in the distance is accompanied by the gradual loss of definition in the details of the model.

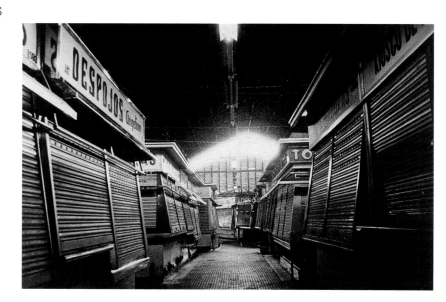

Step 1

We draw two axes and place what will be the vanishing point on the vertical. From this point on we draw the main lines of perspective. On the sketch formed by the perspective lines we draw the market stands, synthesizing their form into simple cubes.

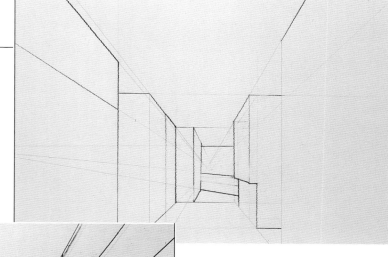

Charcoal, Sanguine Crayon, and Chalk

PRACTICAL
EXERCISES
STEP BY STEP

Perspective
Exercise

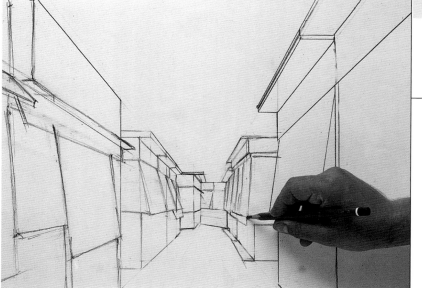

Step 2

Based on the original geometric diagram we draw the specific shape of each stand with a pencil, crudely sketching the first visible volumetric elements of the facade, such as blinds, overhangs, and signs.

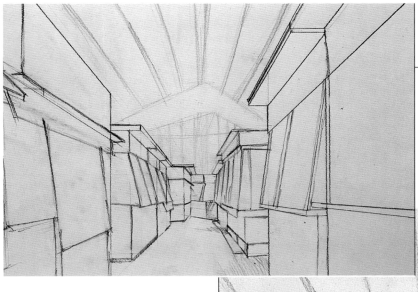

Step 3

Perpendicular lines are drawn with a lighter line, which represent the metal structure of the covering. As we can see, the ceiling beams converge at that single initial point.

Step 4

We add horizontal lines to the drawing, following the plane, to darken the most shaded areas of the overhangs and the blinds.

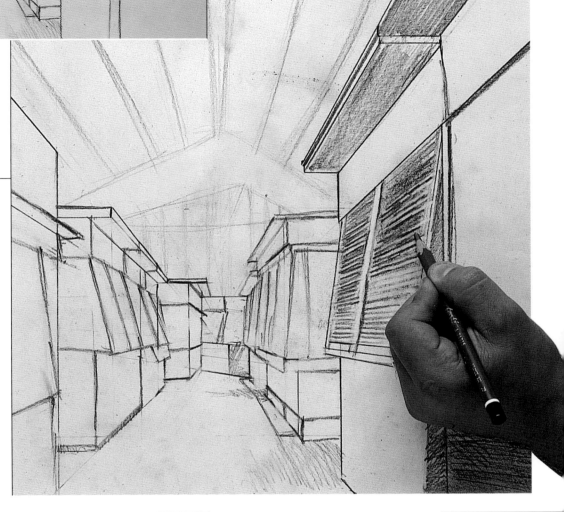

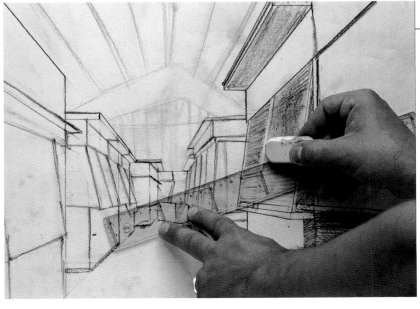

Step 5

The artist decides to highlight some areas of the initial shading with an eraser. To do this, a plastic ruler is used as a guide for following the series of parallel lines that define the surface of the blind.

PRACTICAL EXERCISES STEP BY STEP

Perspective Exercise

Step 6

Contrasts are created when areas of light and dark are close together. The darker part is a simple reinforcement of the line in the same area.

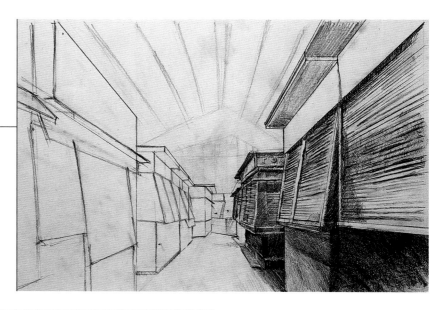

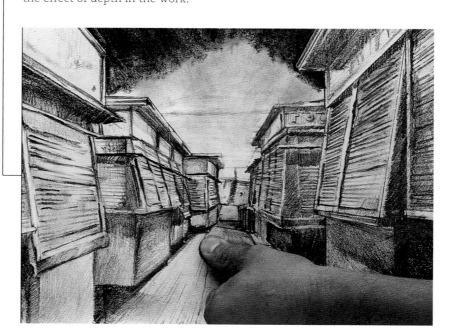

Step 7

With the compressed charcoal pencil we increase the contrast in the darkest areas and reinforce the lines that define the texture, so characteristic of blinds. As the lines recede from the viewer, they appear less precise, and vague.

Step 8

Using a finger, we wipe the lines of the farthest stand, which must be represented more vaguely and with somewhat lighter tones than the ones in the foreground. The lightening of the tone in the distance contributes to the effect of depth in the work.

Charcoal, Sanguine Crayon, and Chalk

PRACTICAL
EXERCISES
STEP BY STEP

Perspective
Exercise

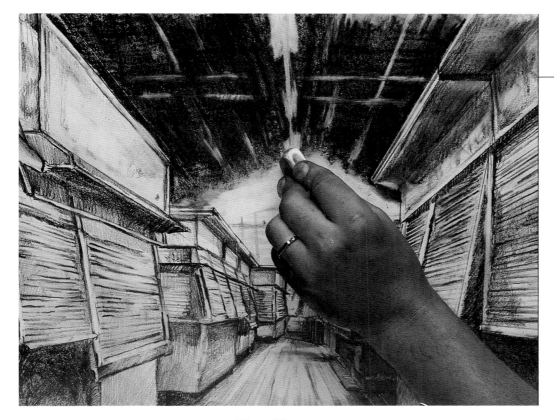

Step 9

The row of fluorescent lights in the ceiling, as well as the spaces between them, are represented by highlighting areas with an eraser.

Step 10

We intensify the contrasts of the various dark areas of the model to define the darkest shadows and the medium ones. This step is carried out using compressed charcoal.

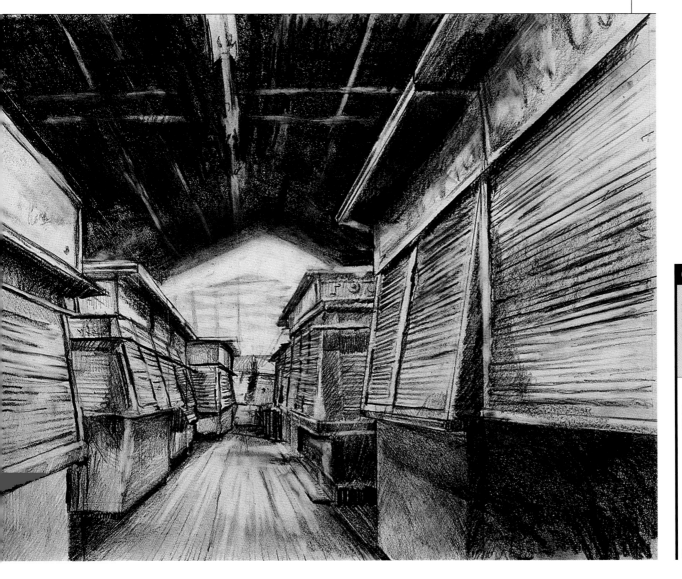

Charcoal, Sanguine Crayon, and Chalk

PRACTICAL
EXERCISES
STEP BY STEP

Perspective
Exercise

Two Figures

Drawing the human figure represents a greater challenge than all other subjects, because here the proportions, the relationships between the forms, and the line reveal a reality that is very close to the viewer and to the artist, making it difficult for an error to go unnoticed. Therefore, to begin we will limit the scope of this exercise to the synthesis of the shapes based on a sketch. Practicing with this drawing will make it easier to understand more elaborate drawings later.

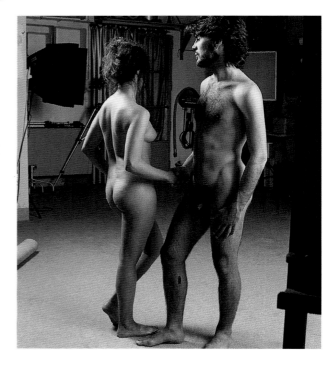

Step 1

We squint at the models until we cannot see any details. Then we begin the drawing with two areas of color that establish the main dark areas. The areas of light are represented by the color of the paper.

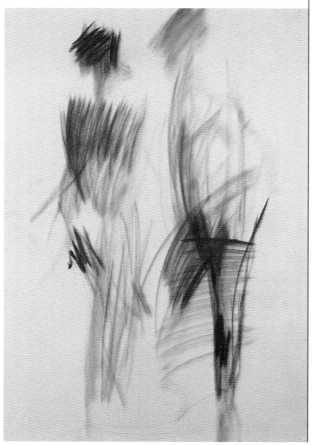

Step 2

Using a wet brush that is charged with pure sepia pigment, we model the main shaded areas and further define the shapes of the bodies.

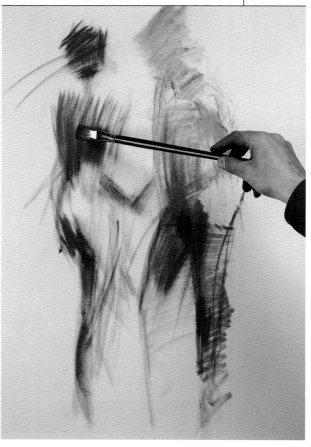

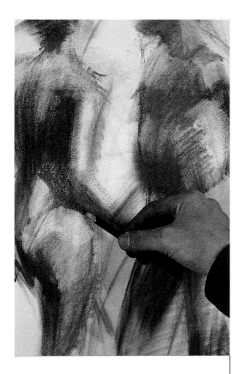

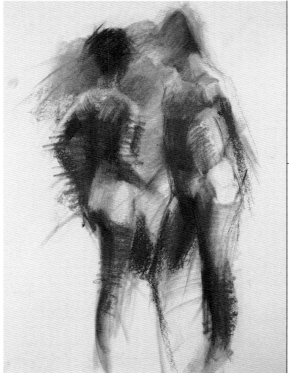

Step 4

We make lines with a blending stump that help define the paper. The anatomical shapes are further detailed, working in only the darkest areas.

Step 3

With a charcoal pencil we define some of the tonal variations that differentiate the extremities or that detail the anatomy. We draw a slanted line that increases the shadow of the back and a dark line that helps define the shape of the forearm.

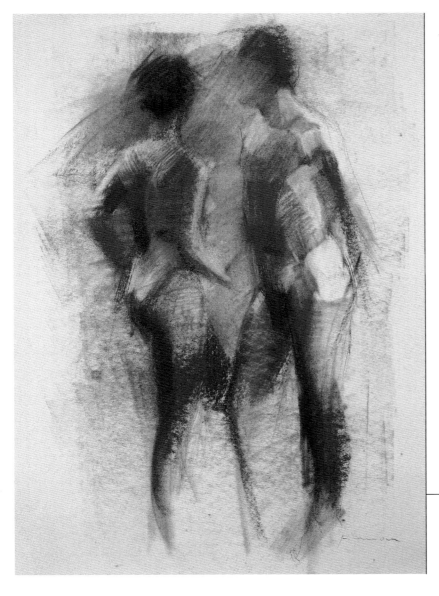

Step 5

Since we are using colored paper, applications of white chalk are going to be used to define the volumes based on the areas of brightest reflected light.

Step 6

Finally, all that is left to do is to make some lines more precise to define the anatomy of these two models based on streaks of light and shadow.

71

Male Nude

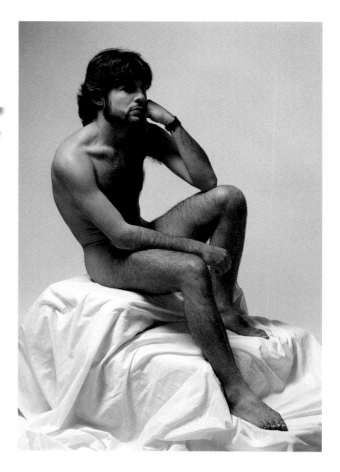

MATERIALS

- Light gray, medium-texture drawing paper
- Kneaded eraser
- Charcoal
- Spray fixative
- Rag
- Blending stump

Charcoal is the most popular medium for working with nudes. The following exercise begins with a paper whose surface has been covered with charcoal. The form will be drawn by erasing the lightest areas. We are interested only in the construction of this drawing. Details such as lines, contrasts of light and shadow, and the study of the pose are not as important.

Step 1

Using the side of the charcoal stick, we shade the entire surface of the paper. Then we blend the background with our hand to create an even tone.

Step 2

We indicate the main areas of light on the figure, using a kneaded eraser. If it becomes dirty it should be kneaded until the eraser absorbs the dust.

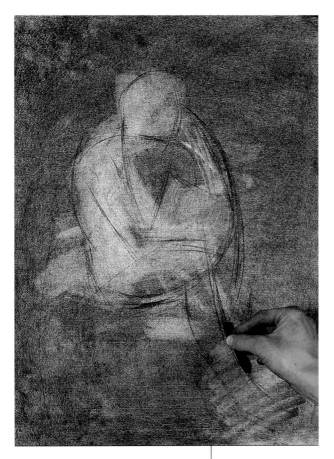

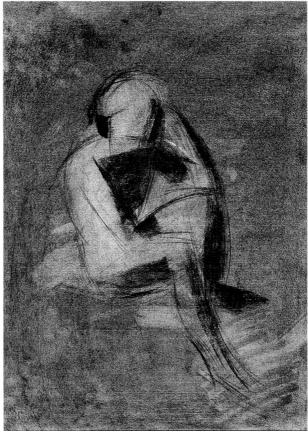

Step 3

The illuminated areas serve as the basis to define the shapes of the model. We make the principal lines that determine the rhythm of the figure with the side of the charcoal stick.

Step 4

Then we take a piece of charcoal and use it to darken the main areas of shadow. Notice the structural character of the drawing.

Step 5

We wipe away some of the tone of the background, using a rag. We must be careful when erasing the background around the outline of the drawing to protect the important lines.

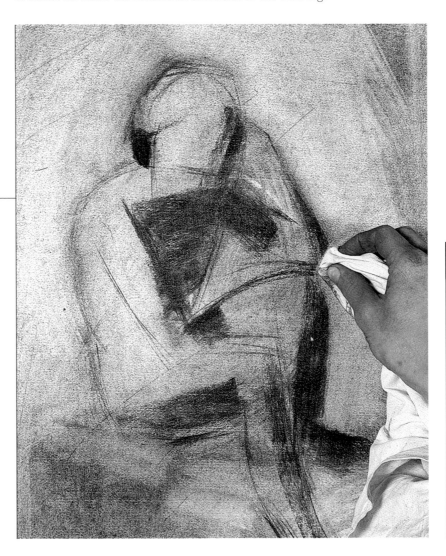

Step 6

With the kneaded eraser we create new contrasting highlights, always flat, without modeling, without detailing shapes too much. As can be seen, these highlights are appropriate, and they occupy specific areas.

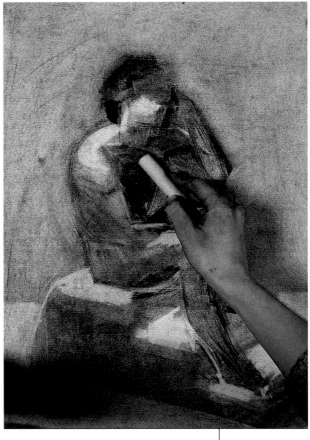

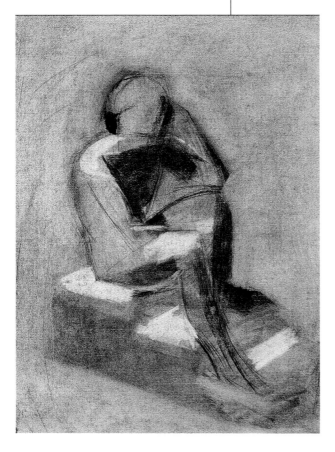

Step 7

Erasing is now more selective. With the tip of the eraser we make the face and the neck. We use the blending stump to extend some of the pigment, without removing it completely.

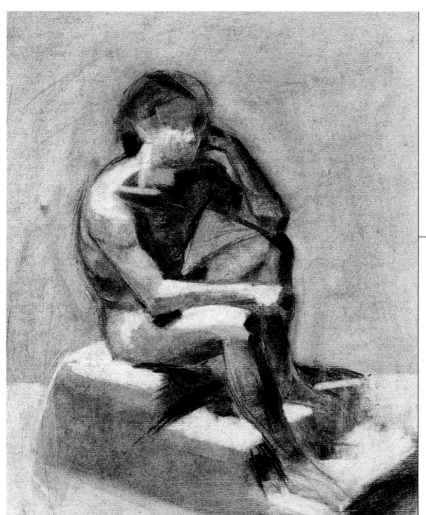

PRACTICAL
EXERCISES
STEP BY STEP

Male Nude

Step 8

We reinforce the most prominent contrasts, using charcoal. This way, the lightest areas are defined by their shadows, and the anatomy is perfectly described through tonal planes.

Step 9

With the edge of the eraser, we make short and parallel lines to suggest the texture and the folds of the cloth that covers the pedestal. Then with heavy lines we reinforce the shadows on the steps.

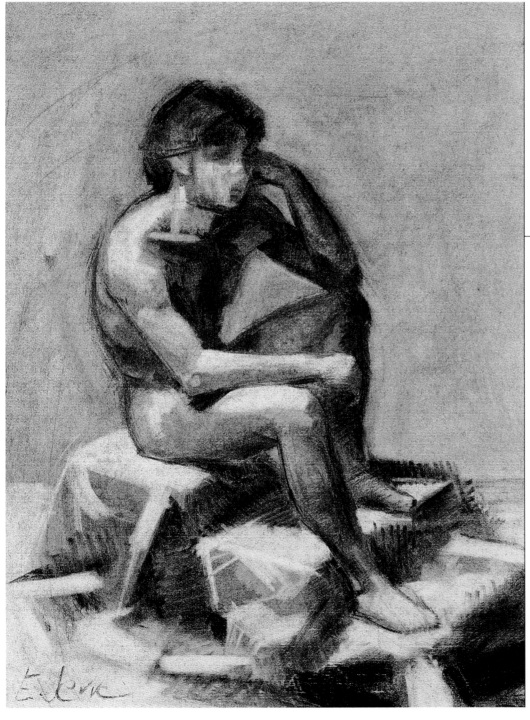

Step 10

The advanced stage of the modeling can be appreciated after the final application of the contrasts and blending around the outline of the arms and face. In reality, this is not difficult, because the areas of light and shadow are quite clear in the model. To finish it we apply the fixative.

Charcoal, Sanguine Crayon, and Chalk

PRACTICAL
EXERCISES
STEP BY STEP

Male Nude

75

Nude Drawn with Shadows

MATERIALS

- Cream-colored, medium-texture drawing paper
- Eraser
- Blending stump
- Sanguine
- Flat brush
- Sable hair brush
- Spray fixative (optional)
- Rags

In an earlier exercise we began to understand the figure created with shadows. In this exercise we will again practice developing the volume of the shapes based on dark areas. Direct shading can make it easier to understand the volumes and the main areas of light and shadow. We illustrate this wonderful technique using sanguine, with which we will make the drawing by laying down areas of color. This will help us to overcome difficulties that were previously considered insurmountable.

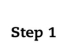

Step 1

Using sanguine, we begin the layout with a quick sketching of the main dark areas and of other areas that border the lightest points. The most important lines are the one that defines the neck and the nape, the one at the shoulders, and those that determine the arms and legs.

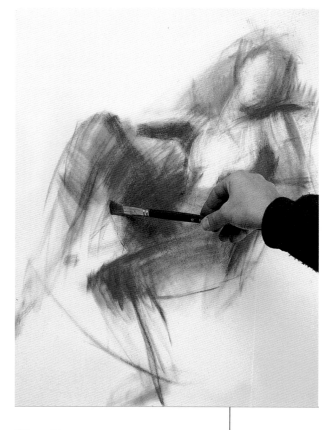

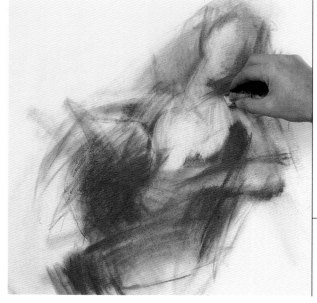

Step 3

Using a sable hair brush with coarse bristles, we blend the initial sanguine shadows. From the initial lines, we extend the pigment over the shaded areas, omitting any details.

Step 2

To strengthen the contrast between light and shadow we lighten areas with the eraser at the points that require greater luminosity. The marked contrast between light and shadow contributes to the representation of volume.

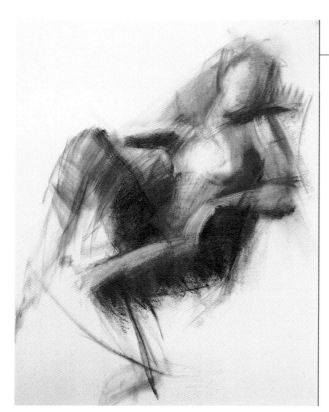

Step 4

The progression of the contrasts on the body must be done gradually, while searching for the values of the surfaces according to the light that reflects from each one of them.

Step 5

The blending stump allows us to remove color with light strokes. The surfaces with most light have no edges, and they penetrate the shaded planes.

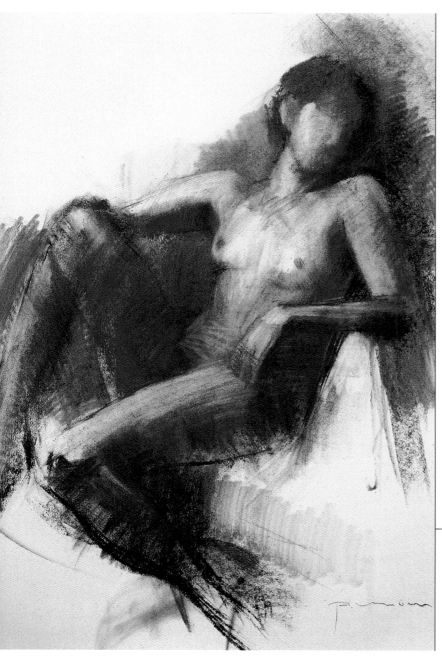

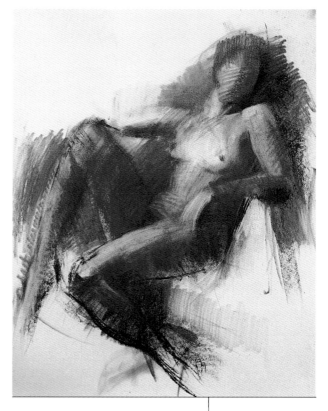

Step 6

We define the planes that help illustrate the form with repeated lines of sepia and sanguine that reinforce the anatomy. Notice how the calf of the leg is treated, and the definition of the fingers on the leg.

Step 7

To conclude, we contrast the darkest areas with sepia and go over some of the lines that separate the figure from the background. This can be done with damp sanguine so it can be more compacted on the paper. Then we apply the fixative.

Charcoal, Sanguine Crayon, and Chalk

PRACTICAL
EXERCISES
STEP BY STEP

Nude Drawn
with Shadows

Female Nude

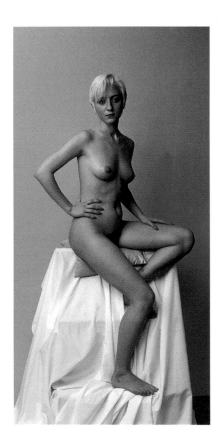

Conté crayon

MATERIALS

- Colored chalks
- Rough, colored paper
- Drawing board
- Clean rags

A nude figure provides the best way for understanding the anatomy and the relationship of the different parts of the body. In this exercise we hope to introduce the amateur to what it is like to do a study of a model with colored chalks. The small sticks of sanguine and ochre crayons and white and black chalks combine perfectly to describe the qualities of the flesh of the model. The opacity of the chalk also allows the artist to define the contours and the darkest shadows of the body more vividly.

Charcoal, Sanguine Crayon, and Chalk

PRACTICAL
EXERCISES
STEP BY STEP

Female Nude

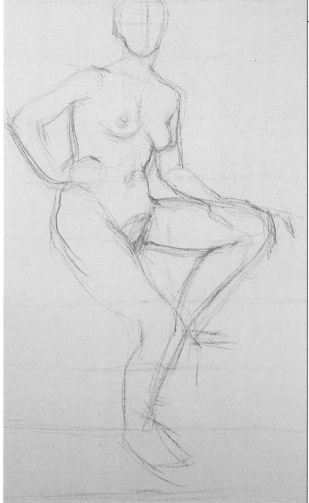

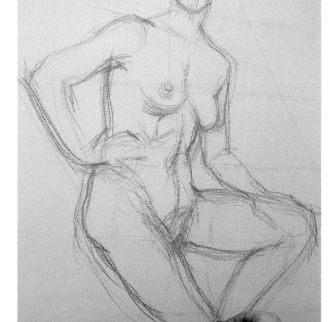

Step 1

We begin by drawing the contour of the figure with a light line. The structure of the figure unites the various parts and seeks the relationship of their proportions.

Step 2

To understand the forms of the human body it is important to learn how to represent it beginning with geometric references and lines that will help us structure its shapes and volumes.

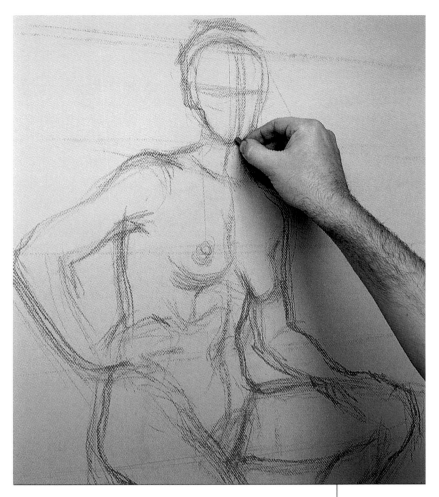

Step 3

Building on the initial drawing, we continue to work on the profile of the figure until we achieve the specific shape of each limb, reinforcing the principal lines of the anatomy.

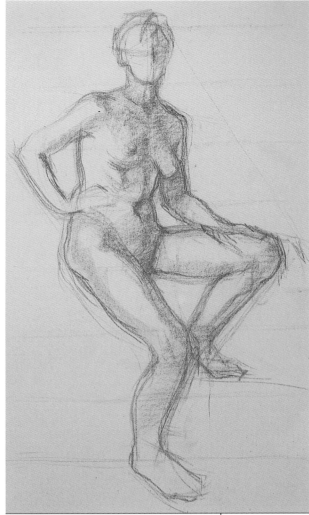

Step 4

We sketch the darkest areas with the side of the sanguine stick, so that the volume is indicated with uniform shading. Then, using a rag, we rub the shading gently to soften the lines.

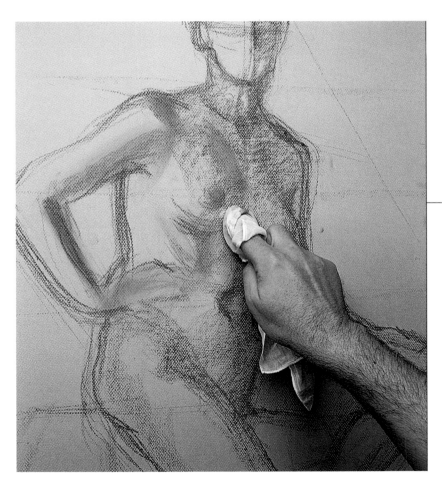

Step 5

We lighten the dark areas of the body, blending them with a clean rag, and integrating the tone over the color of the paper. We model the shadows until the gradations of the tones follow the planes of the body.

PRACTICAL
EXERCISES
STEP BY STEP

Female Nude

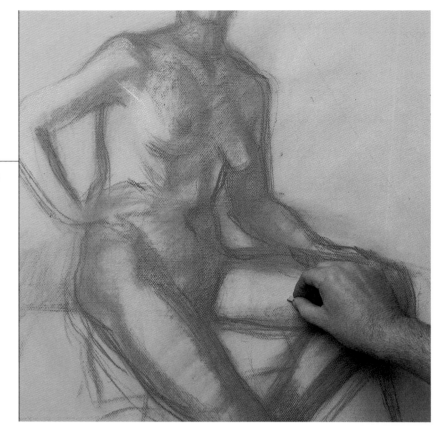

Step 6

We apply light tones to highlight the illuminated areas of the figure. We draw them gradually, increasing the pressure of the chalk as needed to create the lighter areas.

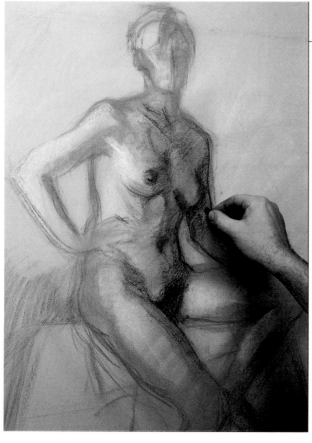

Step 7

Once the drawing has been consolidated, we reinforce the main lines by applying the first dark tones on the inside of the arm, pubic area, and torso. The dark shading breaks up the main highlights and helps emphasize the volume of the body.

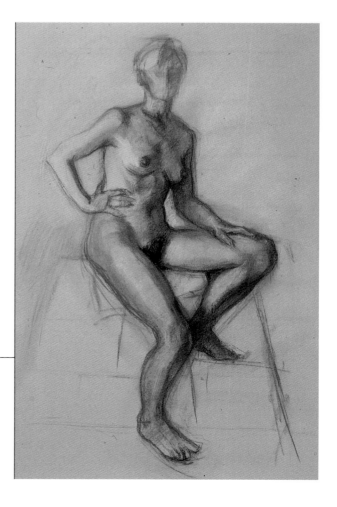

Step 8

We rub the tones and colors with the fingers to unify them, and we go on to add new lines over them to increase and bring out the highlights and shadows.

Step 9

Using white chalk to loosely apply highlights, we bring out the folds of the fabric upon which the model is sitting. If the light areas are represented with white chalk, the shaded areas are represented by the color of the paper.

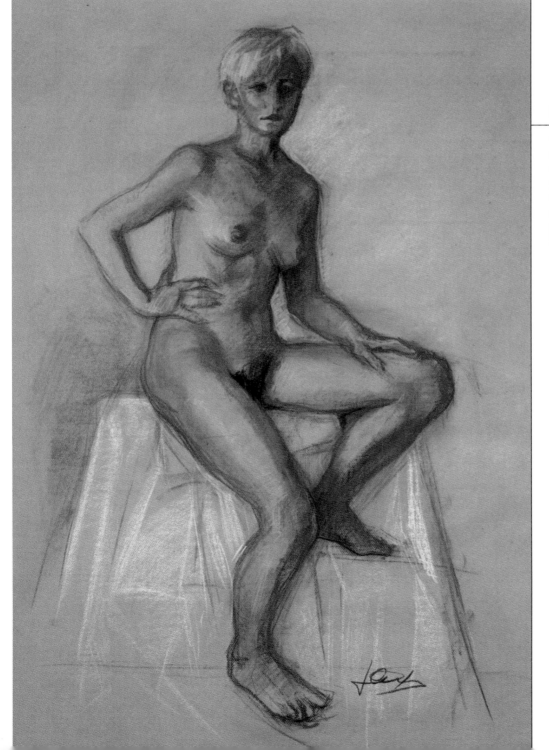

Step 10

We cover the background with a violet and gray wash that we blend with our hand. We draw the facial features, without getting caught up in small details. Then we can consider this study finished, perfectly in harmony as far as color is concerned.

Value Study
of a Figure

Charcoal

Sanguine

White chalk

MATERIALS

- Charcoal, sanguine, and chalk
- Eraser
- Tan-colored paper
- Drawing board
- Thumbtacks
- Rag

A value study is the modeling of forms using tonal gradation. This will act as a base for shading. The representation of the figure with tonal values makes it possible to study the model according to the light that it reflects. This light can be emphasized with white highlights, when colored paper is used.

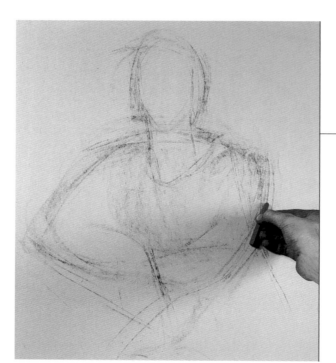

Step 1

Holding the sanguine stick flat, we begin to draw. We roughly establish the outline while defining the volume of each area of the figure with the lines.

PRACTICAL
EXERCISES
STEP BY STEP

Value Study
of a Figure

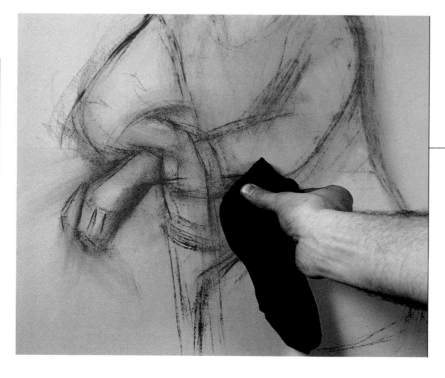

Step 2

After the initial sketch and with the drawing completely outlined, we blend the sanguine marks with a rag. This allows us to diffuse the line and to blend it with the tone of the paper.

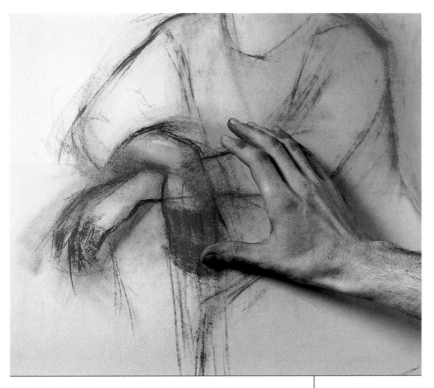

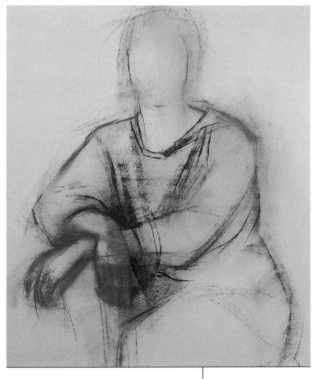

Step 3

As we finish sketching the different parts of the body, like the hands, we begin to work on the dark areas, shading them with sanguine, which will become lighter as we rub them with the hand.

Step 4

After the subtle work on the hands, the initial sketch should give way to the first dark areas. Using the side of the charcoal stick, we increase the contrasts around the hands and the folds of the dress.

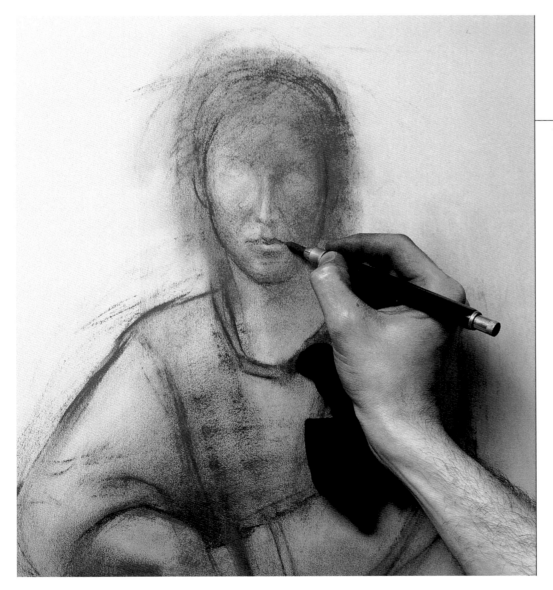

Step 5

With the sharp point of a round piece of chalk, we define the shapes of the facial features. In a drawing such as this one, the most important thing is to find the facial expression based on its proportions.

Charcoal, Sanguine Crayon, and Chalk

PRACTICAL
EXERCISES
STEP BY STEP

Value Study
of a Figure

Step 6

We shade the main areas of the face with the sanguine crayon. Rubbing with the finger and the line shading produce delicate tonal gradations that model the facial features.

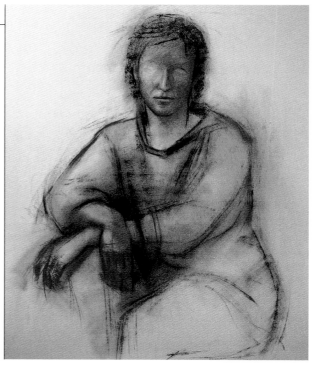

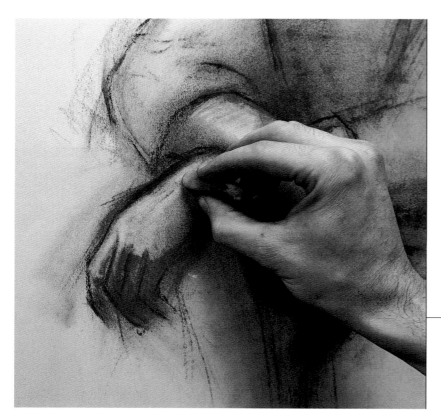

Step 7

We begin to highlight areas of skin tones with the eraser, outlining the shapes and emphasizing the structure of the parts of the body. To counteract the excessive light of the paper, we can touch up the highlights made with the eraser by using our fingers.

Step 8

We redraw, blend, and touch up the facial features in more detail. The values of the black charcoal are combined with the sanguine on the dress, completing it by lightly blending with the fingers.

Charcoal, Sanguine Crayon, and Chalk

PRACTICAL
EXERCISES
STEP BY STEP

Value Study
of a Figure

84

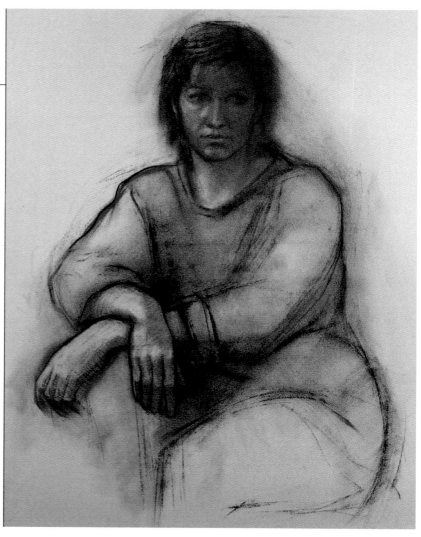

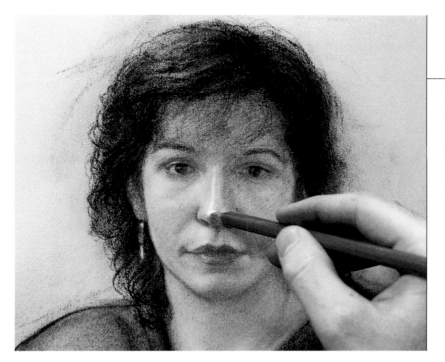

Step 9

With a white chalk pencil, we lighten the large illuminated areas of the face. The white highlights are complemented with the linear drawing of the hair, the eyebrows, and the eyes, and the careful modeling of the lips.

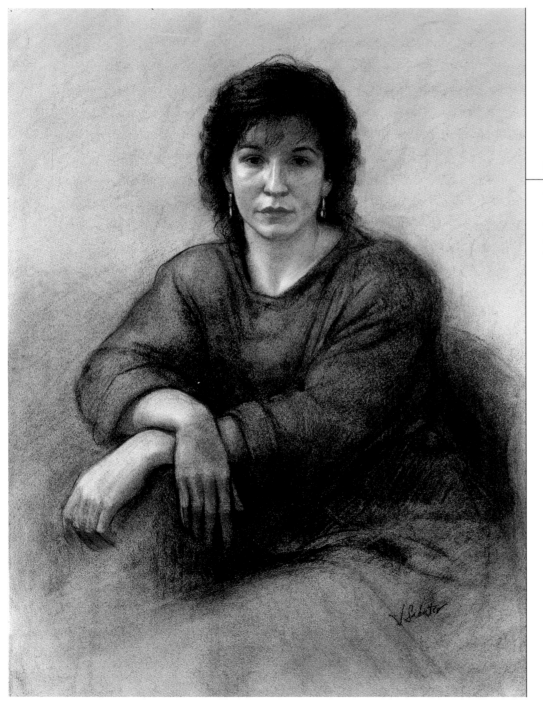

Step 10

We blend the contours of the face and we highlight the reflected light with white chalk. This way we create a soft blend of tones. Then we use charcoal to define the darkest areas.

Charcoal, Sanguine Crayon, and Chalk

PRACTICAL
EXERCISES
STEP BY STEP

Value Study
of a Figure

85

Portrait
of a Child

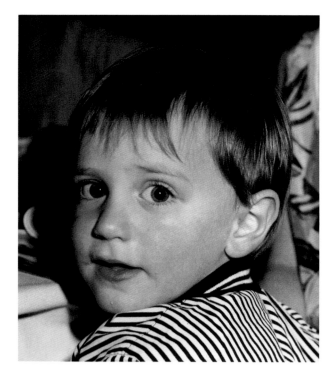

Charcoal

MATERIALS

- Medium-texture drawing paper
- Eraser
- Charcoal
- Spray fixative (optional)
- Rags

Every good portrait requires a detailed preliminary drawing. The following exercise, a child's portrait, does not hold great technical difficulty. It is a matter of putting into practice some of the main drawing techniques with charcoal. We will begin with an old method: the grid. With this technique it is possible to enlarge any type of images while maintaining the proportions.

Step 1

We draw a perfect grid on tracing paper and place it over the photograph that we wish to enlarge. The shorter the distance between the parallel lines, the more detailed the copy will be.

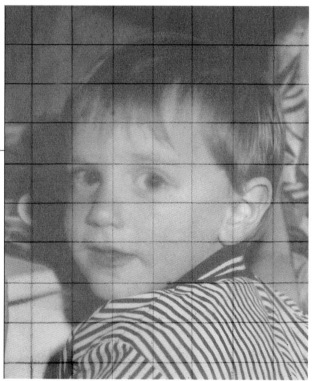

Charcoal, Sanguine Crayon, and Chalk

PRACTICAL
EXERCISES
STEP BY STEP

Portrait
of a Child

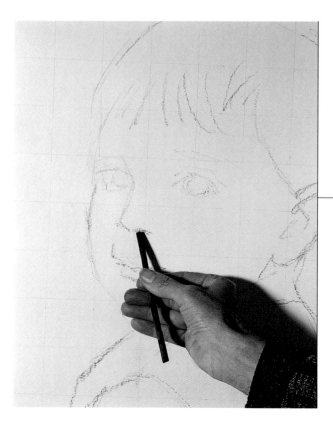

Step 2

We grid the drawing paper with as many spaces as the tracing paper on the photograph. The sketch must be done using large gestural lines, without any type of shadows. To create a drawing with good proportions, we must simply arrange the model on a series of common coordinates.

Step 3

The charcoal line should be light, hardly pressing it on the paper, to allow for possible corrections. We make sure that the eyes, nose, and mouth are correctly positioned.

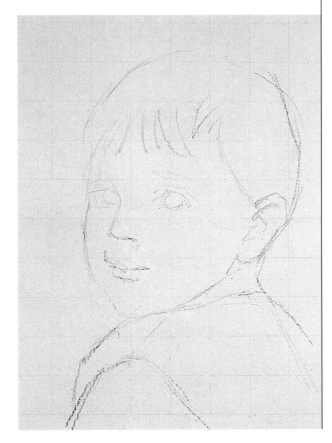

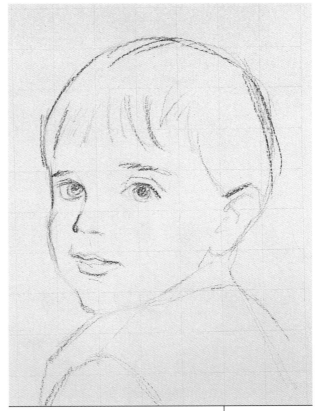

Step 4

When the desired resemblance has been achieved, we erase the grid and retrace the profile with stronger lines, making sure that they appear more definite.

Step 5

We begin the shading of the hair, which frames the shape of the cranium. We make sure that the direction of the hair and its thickness are correct. We draw the shape of the eyes and the outlines of the neck and the clothing with more intensity.

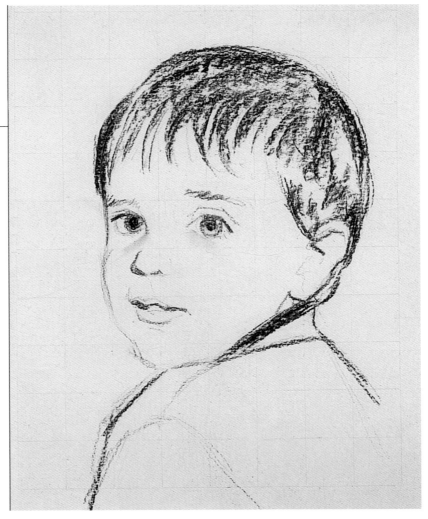

Charcoal, Sanguine Crayon, and Chalk

PRACTICAL
EXERCISES
STEP BY STEP

Portrait
of a Child

87

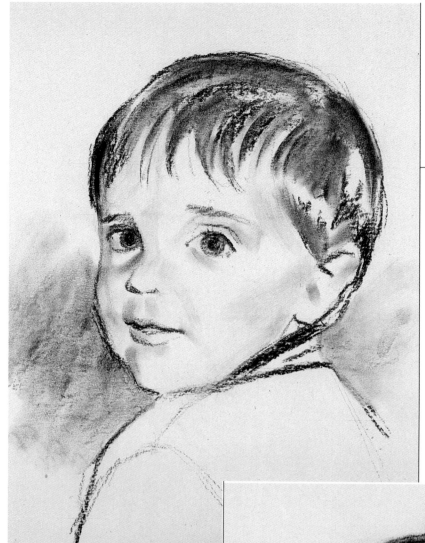

Step 6

We blend the lines of the hair with the tips of our fingers, and then with additional shading, we wipe the background to bring out the profile of the face. Next, with the tips of the fingers covered with charcoal, we define the features with very soft tones.

Step 7

We clean the shape of the face and use the eraser to remove any unnecessary marks. With a piece of charcoal held flat, we darken the hair. To create the correct texture, it is important for the new shading to follow the direction of the hairstyle.

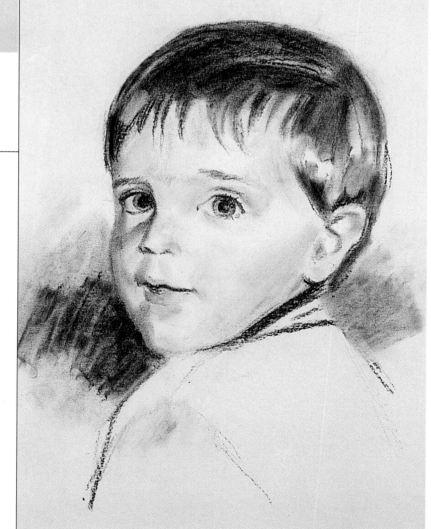

Charcoal, Sanguine Crayon, and Chalk

PRACTICAL
EXERCISES
STEP BY STEP

Portrait
of a Child

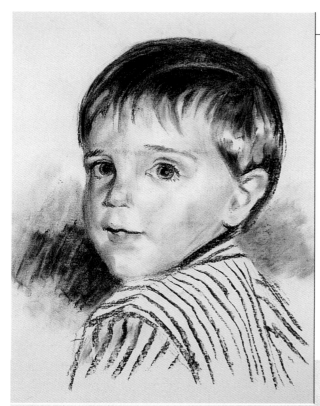

Step 8

We make new lines on top of the previous ones to darken the hair, retrace the shapes of the eyes, and draw the lines on the outfit, keeping in mind that they should not be straight but molded to the shape of the torso.

Step 9

We wipe the background with darker shadows and blend and apply the last contrasts on the face, without marking them too much, because the facial features of a child are not as pronounced as those of an adult. To finish we spray it with fixative.

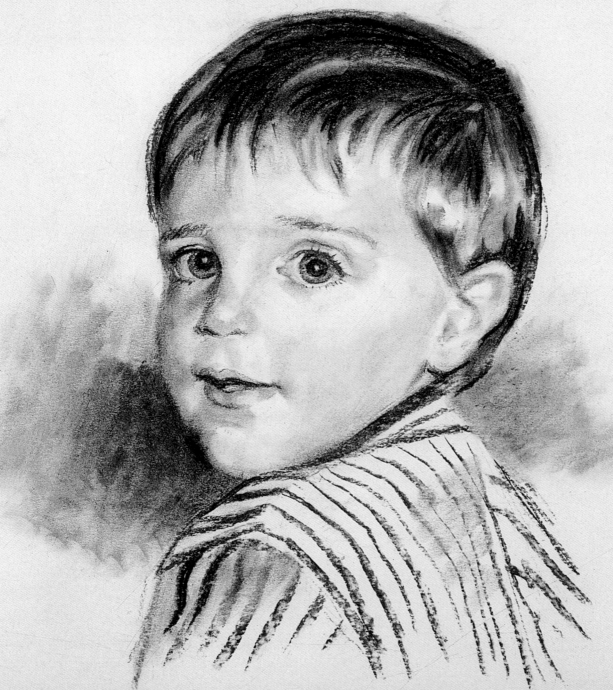

Charcoal, Sanguine Crayon, and Chalk

PRACTICAL
EXERCISES
STEP BY STEP

Portrait
of a Child

Portrait
of an Elderly Woman

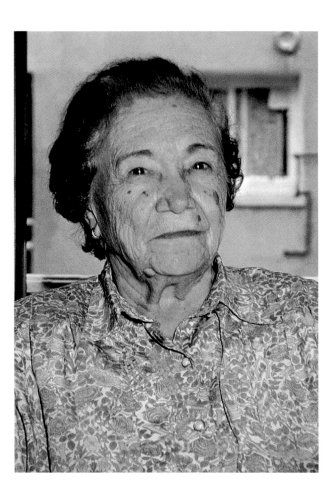

We have elected to draw the face of an eighty-year-old woman. This is quite an advanced age, so all those features that define age will be very apparent in this case. We will use sanguine for this exercise, combined with charcoal and black, ochre, and white chalk. When working in "three colors," an ochre-colored paper is very useful to reinforce the selected earth tones.

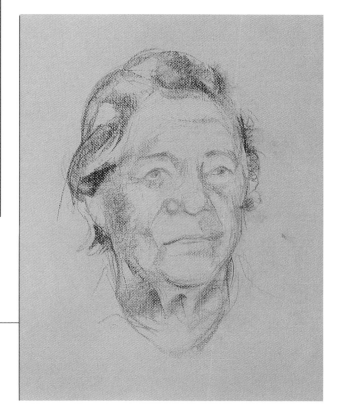

Step 1

We sketch and establish the main facial features of the woman, applying light pressure on a sanguine stick. This is an essential step, especially in complex portraits such as this one.

Step 2

We highlight the drawing by applying shading with a piece of sanguine to define the hair, and a different shading with ochre chalk for the dark areas.

Charcoal, Sanguine Crayon, and Chalk

PRACTICAL
EXERCISES
STEP BY STEP

Portrait of an
Elderly Woman

Step 3

We move on to the blending phase. We reserve one end of the stump for blending the darkest areas and the other for the lighter areas.

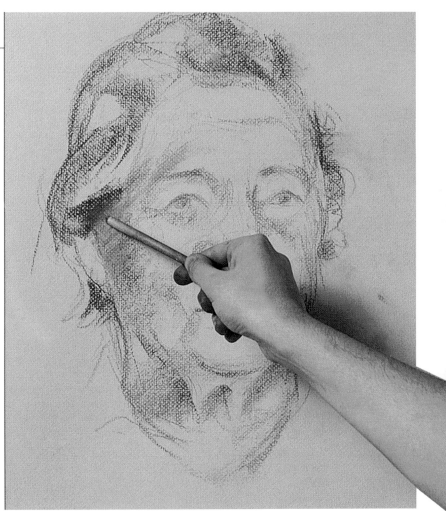

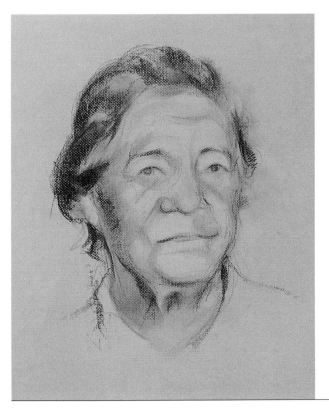

Step 4

This is a gradual task. Once the applied color has been blended, we continue shading the hair with a bistre chalk that is darker than the sanguine color. With the same dark brown color, we mark the shadowy area of the cheek and the flacid skin under the chin.

Step 5

We again blend the color, giving them strength and contrast. We also draw the lines that go from the sides of the nose toward the corners of the mouth. This is one of the features that is accentuated with age.

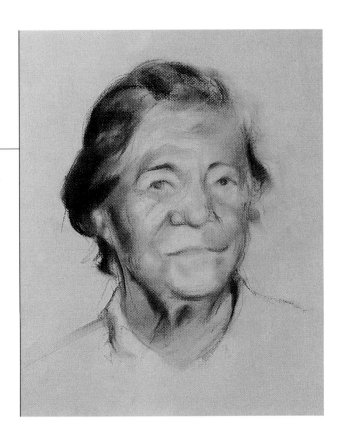

Charcoal, Sanguine Crayon, and Chalk

PRACTICAL
EXERCISES
STEP BY STEP

Portrait of an
Elderly Woman

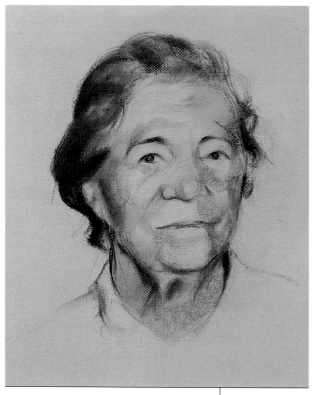

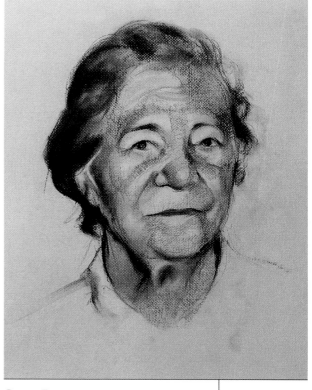

Step 6

As you can see, we have defined and sharpened the features by emphasizing the facial details more than the overall feeling. This process can be noticed clearly in the expression, because the eyes, although small, are perfectly defined with the charcoal pencil.

Step 7

We have brought out the contrasts in the face using charcoal. Special attention must be paid to the light on the model. In this case, the light is quite direct and intense, so the charcoal must be applied to both sides of the face, even blending the strokes into the darkness of the hair.

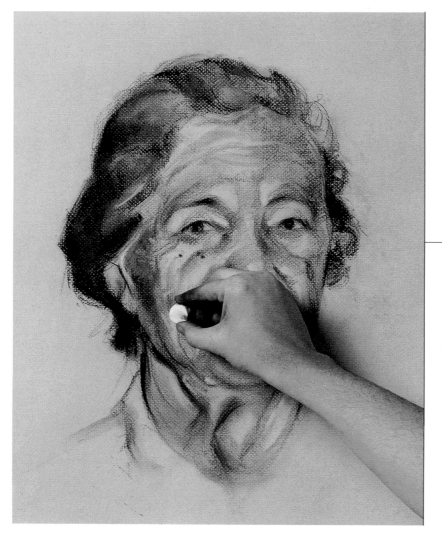

Charcoal, Sanguine Crayon, and Chalk

PRACTICAL
EXERCISES
STEP BY STEP

Portrait of an
Elderly Woman

Step 8

Finally, we introduce white to express the lightest areas of the skin and the brightness of the eyes. Remember that the base color is ochre, so all the highlights that we have created with the eraser will not be as strong as those made with the white chalk.

Step 9

We use Conté pencils to indicate the details of the hair, the reflections of the earrings, and the moles on the face. Using the bistre stick we sketch the collar of the dress.

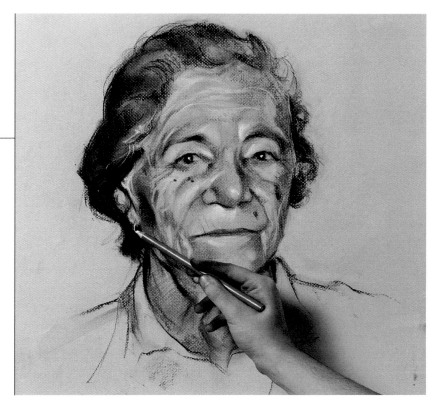

Step 10

To finalize the drawing we have used different tones of bistre chalk, which are in harmony with the sanguine color and help complete the tonal range. A little erasing around the eyes, the forehead, and the mouth will contribute to the representation of the facial wrinkles.

Charcoal, Sanguine Crayon, and Chalk

PRACTICAL
EXERCISES
STEP BY STEP

Portrait of an
Elderly Woman

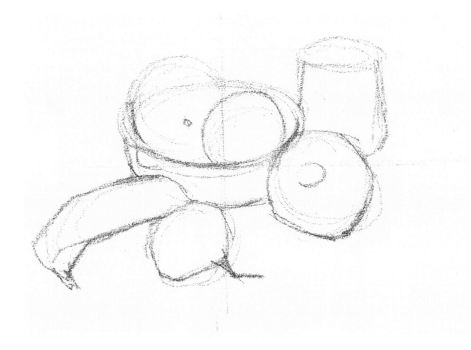

Glossary

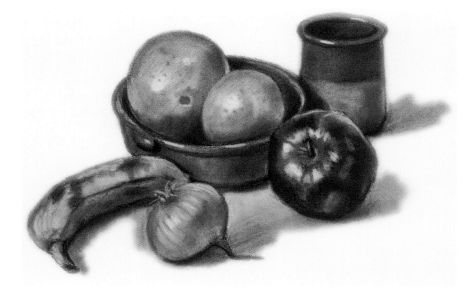

Blending: the action of spreading or wiping charcoal, sanguine crayon, or chalk on paper until it fades away.

Blending stump: a basic tool especially manufactured for blending. It is made of porous paper, formed in the shape of a pencil. It is available in various sizes.

Chalk: in fine arts, a term used to designate the hardest bars of pastel colors. Originally, chalk was obtained from calciferous rocks formed during the Cretaceous Period.

Charcoal: a thin stick of carbonized willow, hazel tree, or rosemary that is used for drawing.

Charcoal pencil: a compressed charcoal stick in a wood sheath. It makes denser lines than a charcoal bar.

Chiaroscuro: those parts or areas of a picture where, even though in shadow of any intensity, the model can still be seen. It can be defined as the art of painting with light in shadow.

Coloring: a technique that is usually juxtaposed with that of line drawings. Also used to describe the application of color. Coloring is a way to cover areas of the paper without lines or gaps, whose only edges are its outside borders.

Composition: this is the placement of the elements that make up the subject. The composition, in large part, depends on the balance of the subject, its framing, and the selected viewpoint.

Contrast: in drawing, it is the juxtaposition of two opposite tones.

Fixative: a liquid in aerosol form that is sprayed on pencil, charcoal, sanguine crayon, chalk, and so on, to fix them so that the media will not come off, smear, or deteriorate. The fixative can also be applied with an atomizer by blowing through one of two metal tubes attached together at an angle.

Framework: a preliminary drawing that attempts to represent the basic lines of the composition of the model.

Gradation: progressive lightening of the value of a tone, going from an intense gray to another, lighter one, avoiding any brusque transition between them.

Hatching: a series of juxtaposed or superimposed lines that simulate shading.

Highlighting: this is the term for the act of restoring the color of a paper that has been shaded or colored. An eraser and white chalk are the tools most commonly used for highlighting.

Imprint: defines the way a drawing is interpreted and executed, related to the finish, the way lines and shadows are laid down, that is to say, the personal style of each artist.

Line drawing: a drawing made with only lines, no shading or crosshatching. A line drawing is a silhouette of the subject that shows the basic structural shapes of the model.

Modeling: refers to shading using several tones in an attempt to create the illusion of three-dimensionality. A modeled drawing is identified by its smooth

transitions of tone rather than brusque tonal contrasts.

Penumbra: middle ground or area of intermediate tones between the most well-lit areas and those that have the most shadow.

Perspective: a technique that attempts a graphic representation of the effects of distance on appearance, form, and color. We can distinguish between linear perspective, which represents the third dimension of depth using lines or geometric shapes, and aerial perspective, which represents depth using colors, tones, and contrast.

Reflection: the effect of concentrated light on a model that can be indicated by erasing or by adding white highlights.

Rubbing: this is the technique of repeatedly wiping the charcoal, sanguine crayon, or chalk with a finger or another tool while applying pressure. This is one of the basic techniques for working with dry media. The difference between blending and rubbing is not always obvious.

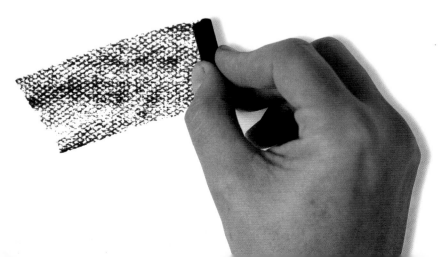

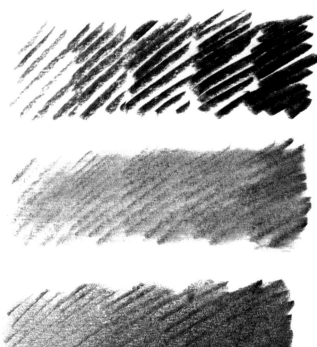

Saturation: the point at which a surface covered with media will not allow the adhesion of more charcoal, sanguine, or chalk.

Shading: the application of grays or crosshatching in a drawing in an attempt to create a three-dimensional effect.

Sketch: a preliminary study for a drawing, from which a more complete drawing can later be made.

Stroke: the mark made by any drawing medium that is created by friction, such as charcoal, sanguine crayon, or chalk.

Symmetry: repetition of the elements of a drawing on both sides of a central point. This constitutes the maximum balance in a composition.

Sanguine crayon: a small square bar of chalk with a reddish sepia color, with characteristics similar to those of pastels, but harder and more compact. Sanguine is used for drawing, using techniques similar to those of charcoal and pastel. It is also available in pencil form.

Texture: the tactile sensation that can be communicated by a particular surface in a drawing. The texture in a drawing will always be related to the surface relief of the object being represented.

Value: the relationship that exists between like tones in the same image. When working with value we compare and resolve the effects of light and shadow through different tones.

Vanishing point: a single point on the horizon where all parallel lines going in any direction converge.

Volatility: the tendency of drawing media to become detached from the drawing.

Wash: a wet drawing medium consisting of colors diluted in water, usually India ink, sepia, or watercolors. A wash is usually monochromatic.